The World I Love to See

and me too!

Love,

Judy

The World I Love to See

photographs by Ulrike Welsch

The Boston Globe/Houghton Mifflin Company Boston

Designed by Tori Brown

Library of Congress Cataloging in Publication Data

Welsch, Ulrike.
 The World I Love To See.

 1. Photography, Artistic. I. Title.
TR654.W42 779'.092'4 76-49624
ISBN O-395-25179-6 ISBN O-395-25400-0 pbk.

Printed in The United States of America

H 10 9 8 7 6 5 4 3 2

Photograph "Nor' Easter," pages 84-85, copyright © 1974, Ulrike Welsch

Preface

I learned to see when I came to America.

It was September of 1964 that I left Germany. I was an immigrant in New Jersey and every day filled me with new impressions. So much intrigued my eye. Until then photography was a hobby, now it was like a discovery.

I photographed everything that seemed friendly and new: Interesting designs, fire escapes in new shapes, faces that were different, new features — and long eyelashes. So much fascination.

I knew about photography technically. I had been a trained druggist in Germany (sort of a chemist, not as sophisticated as a pharmacist) and photography was part of my training.

After a month in New Jersey I came to Boston and in three days got a job as salesclerk in a camera store. My English wasn't so good; I had to learn fast. At that time I used my camera a lot during lunch hour (I used a Rolleicord then, also a Zeiss Contina IIc.)

The hard part was processing film and making prints.

I lived then on Beacon Hill with four roommates. We shared one bathroom and all had to be at work at 9 a.m. What a traffic jam! But they were cooperative, liked my photographs and urged me to sell them. My darkroom was half a closet — part clothes, part chemicals, and a Durst 606 enlarger I brought from Germany. I worked in a kneeling position; it was cramped but I did produce photographs.

I had my first show in a cafe on Newbury street, Boston, and began selling a little to newspapers. It wasn't easy then; everyone told me I had too little experience, which was true. But I was so full of ideas.

So I quit the camera store in mid-1965 and got a summer job in a camp in Colorado, as instructor and photographer. I loved the children, the outdoors, the spirit. We took trips and photographs, the children learned to process their own film and to make prints in our little darkroom. We had a photo contest at the end, and a camp movie.

Before I left Boston I kept saying "I want to be a photographer." When I came back I could say with good feeling, "I am a photographer." I had gained self-confidence and seen the West, all in one trip. And I found a job; I was so lucky.

The Boston Herald-Traveler liked my human interest photos and didn't mind that I was female. I never had. Being a foreigner and a woman had only helped me, never hurt.

When I started work as a Herald staff photographer in January 1966, I truly had a lot to learn, because news events have to be captured when they happen. I did make mistakes but that's the best way to learn: One ought not to make them twice. It did happen to me that I developed my film in water — once; that I had no film in my camera — once; that I forgot to use the synchronization switch — once. But I learned and my colleagues began to accept me.

I covered all assignments: Harsh ones, fun ones, silly ones, beautiful ones. But the one that made the deepest impression was the funeral of Robert F. Kennedy in New York and Washington. I've never forgotten it; there was so much emotion in people's faces.

I stayed at the Herald until it closed in 1972. I'm glad I had a chance to work there — it's where I gradually became a professional.

Within a month I was a part-time photographer at The Boston Globe and by the end of 1973 was on its staff fulltime. Boston Globe editors like feature photos and present them well. Not only I appreciate this, viewers do too. And praise is good nourishment.

Someone once wrote me that one of my photos was the brightest spot on the front page. I like to create that feeling all the time, whether front page or back or a page in between.

Whenever I travel about, I look for the little extra spark: The huge sunflower high on a sixth floor fire escape, the chickens sharing chow with a dog, the ducklings crossing the highway carefully within a posted "Duck crossing."

My own spirit is so important when searching for pictures that speak for themselves, without words. Sometimes when I don't want to talk I find quiet, distant or silhouetted themes. The telephoto lens is my constant companion then. Other days when I feel like a million dollars it is so fulfilling being close to people, catching their moods. These days, people days, are much happier.

There is beauty everywhere — in the most common places, inside and outside of people. We only have to look. My motivation is to brighten the day for readers. Because we smile much too seldom and it is so healthy to see the corners of the mouth turned upwards.

Contents

To me, big cities are beehives, humming and active. I like to stop and find little fragments — sadness, joy and solitude.

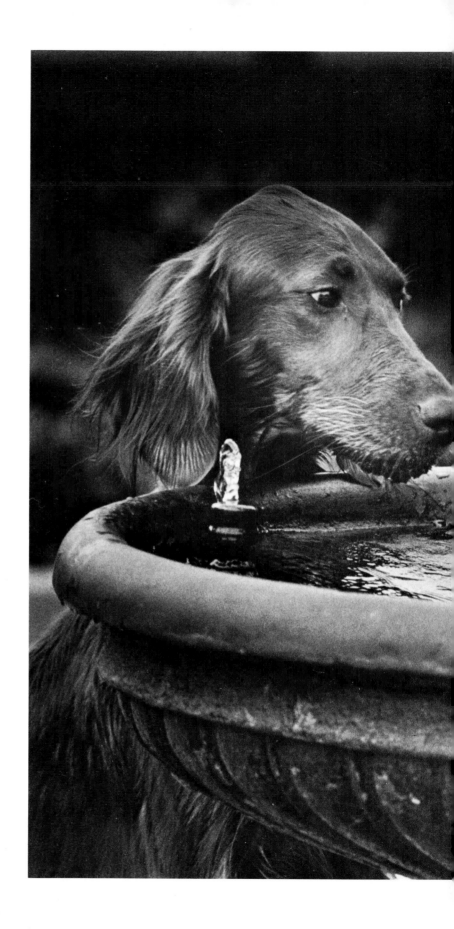

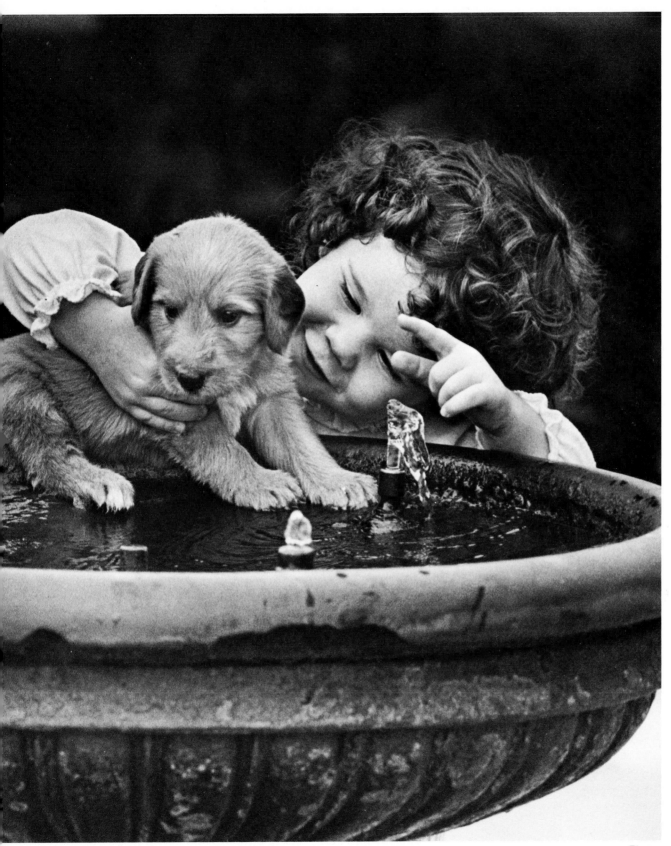

Boston

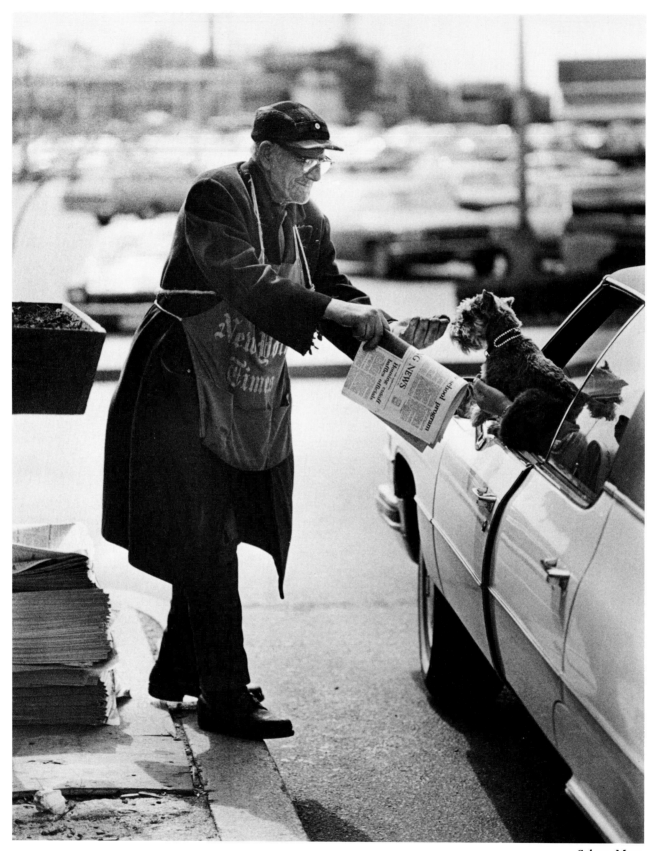

Salem, Mass.

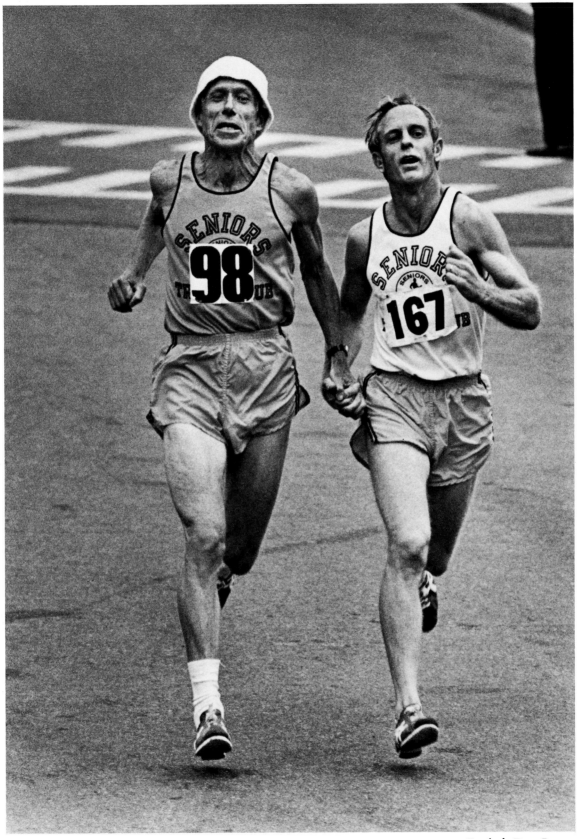

Patriot's Day. Boston

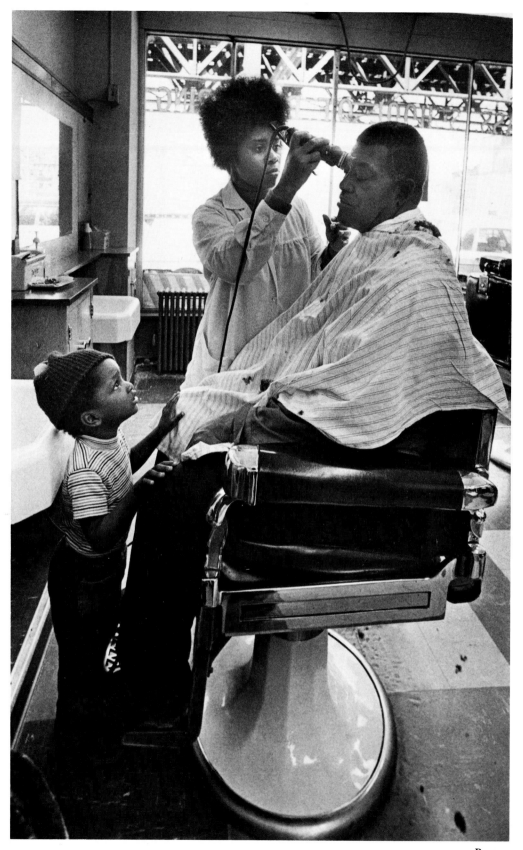

Boston

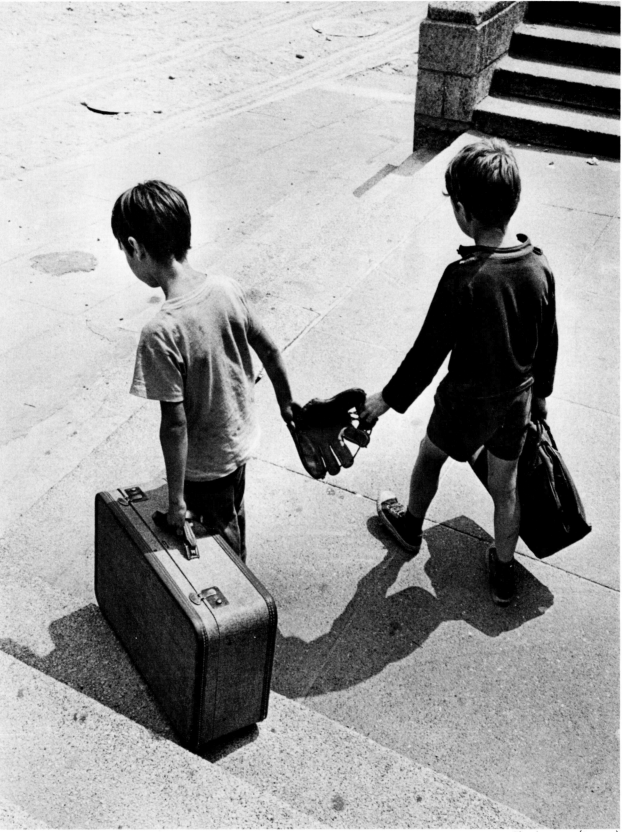

Charlestown (Boston)

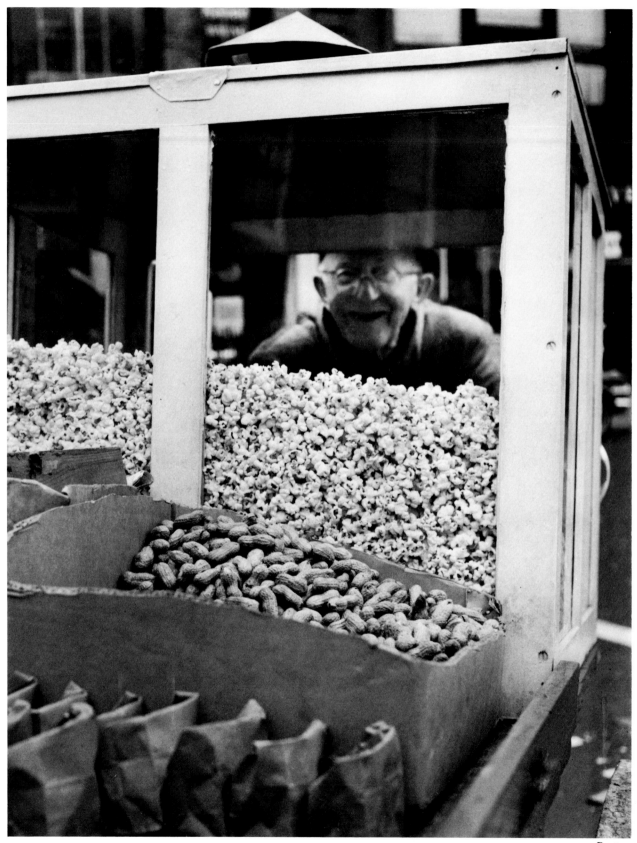

Boston

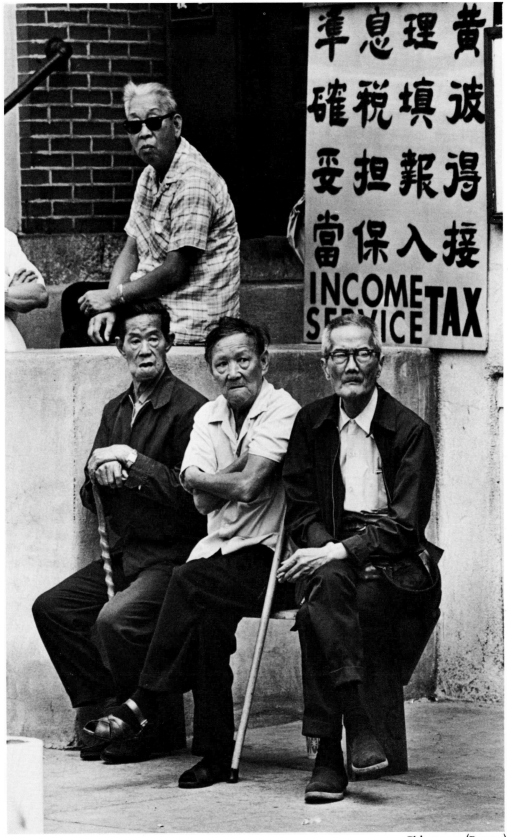

Chinatown (Boston)

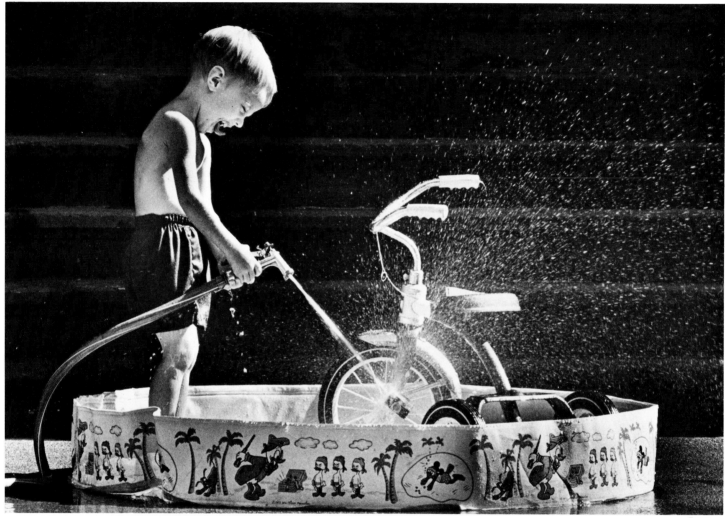

Boston

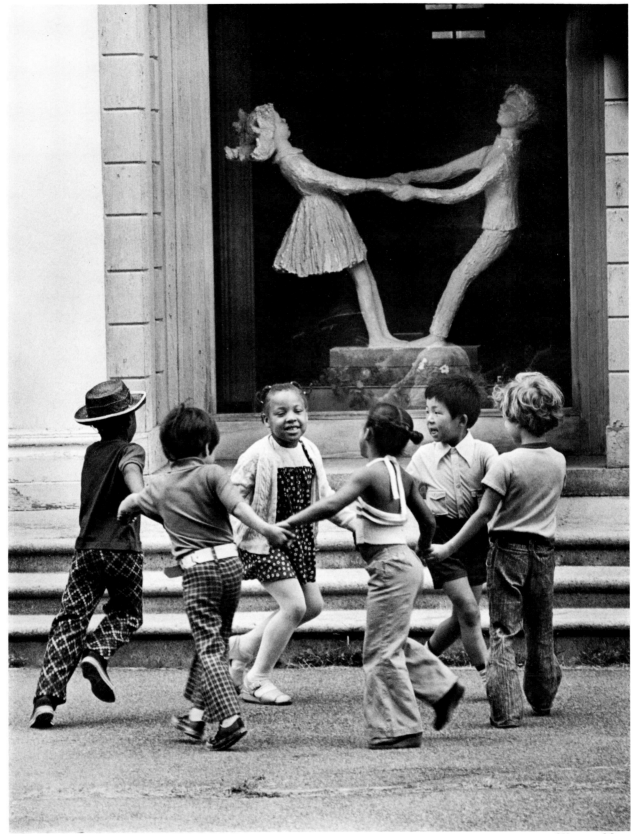

Weston, Mass.

I love this statue in the Public Garden; somehow it's so tender. But, I thought, there ought to be a bird on its hand . . . the gesture is there. I had some bread in my car so I put it all over the statue, into little cracks and onto the hand. I even broke into the ice below while doing it. Then I waited, but pigeons seem so silly; they only picked the crumbs that had fallen on the ground. I was ready to give up, but my radio did not call for me so I kept waiting and finally two pigeons discovered the hand. After this the response was great. Later, the gentleman who posed for the statue some 40 years ago called and said there used to be a bird on the boy's hand but it had broken off. Meanwhile the statue itself had disappeared. Very sad.

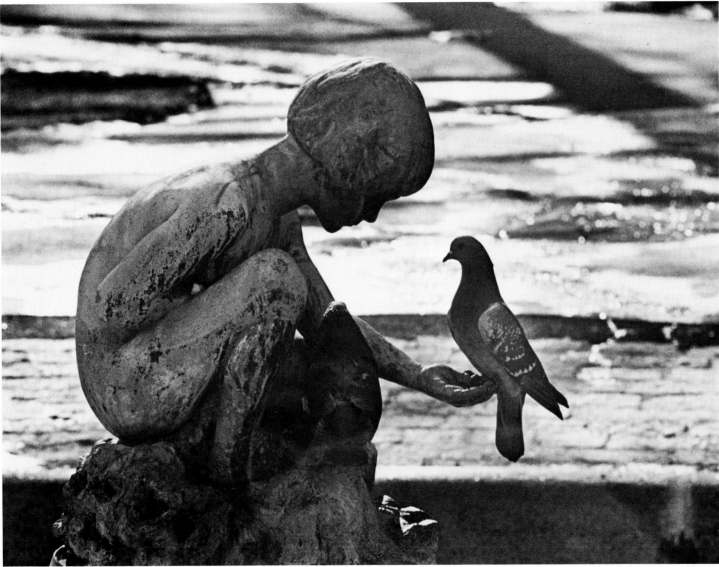

Boston

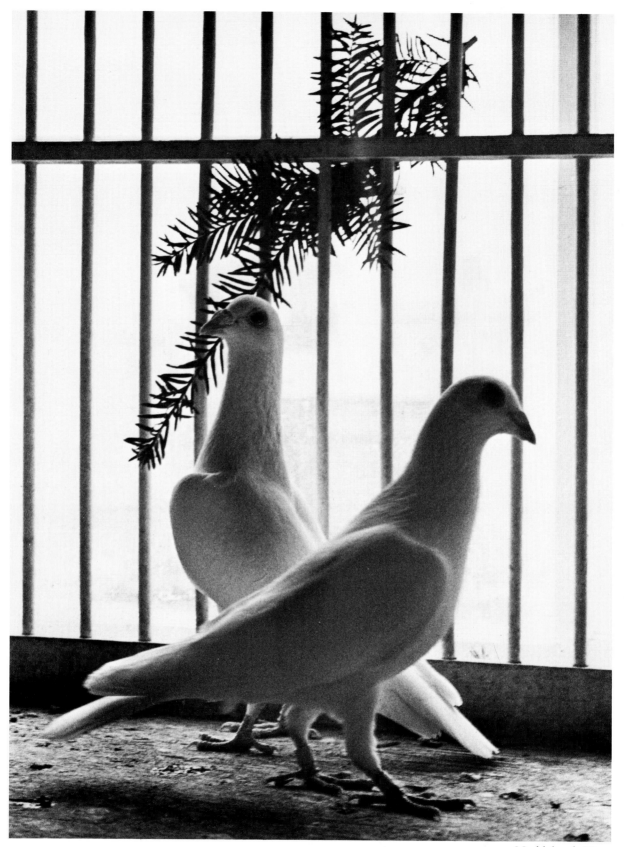

Marblehead, Mass.

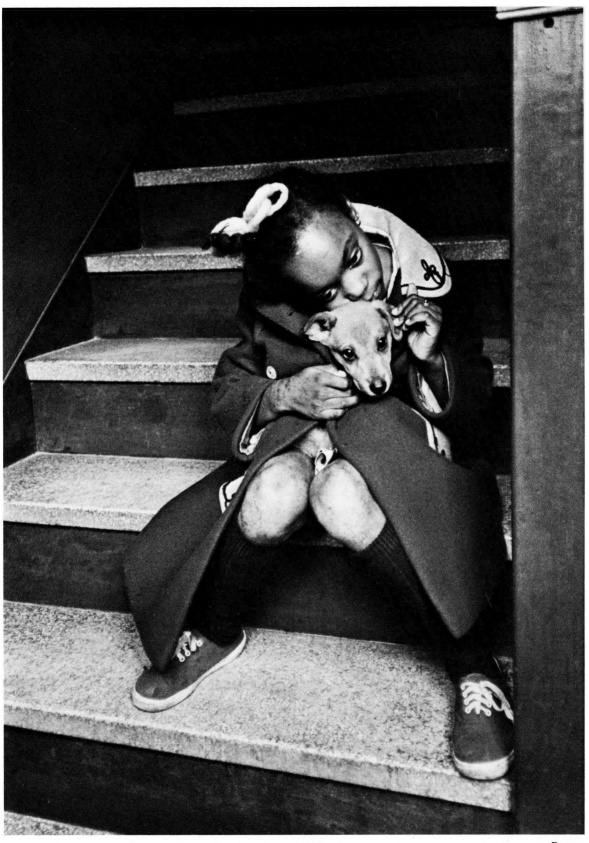

Boston

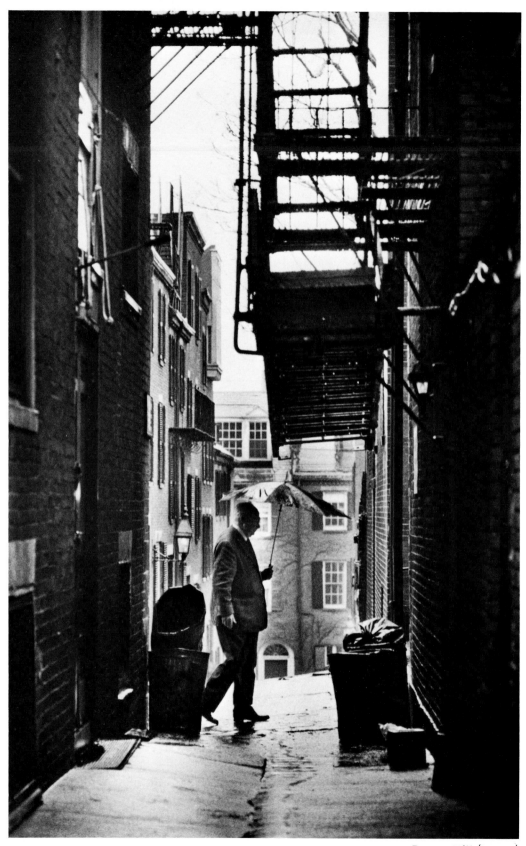

Beacon Hill (Boston)

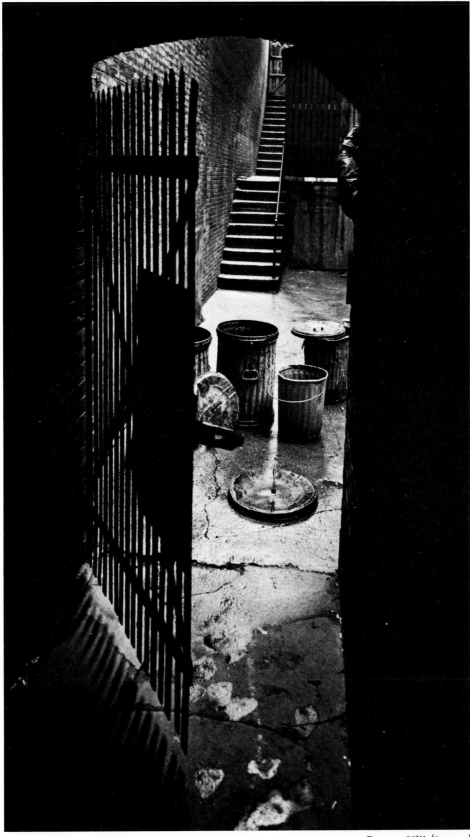

Beacon Hill (Boston)

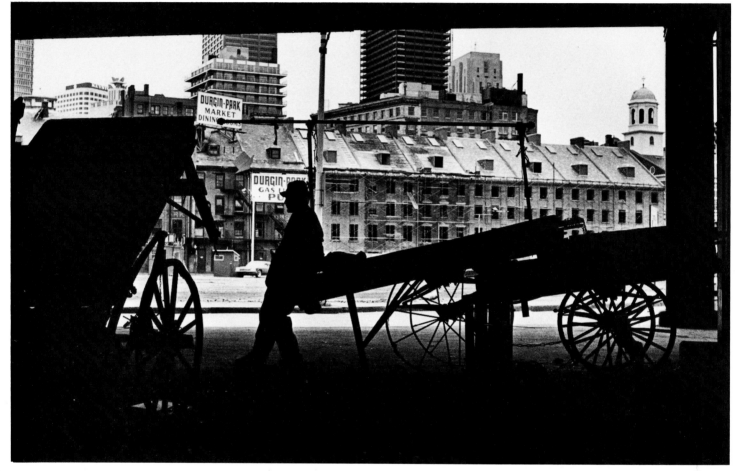

Boston

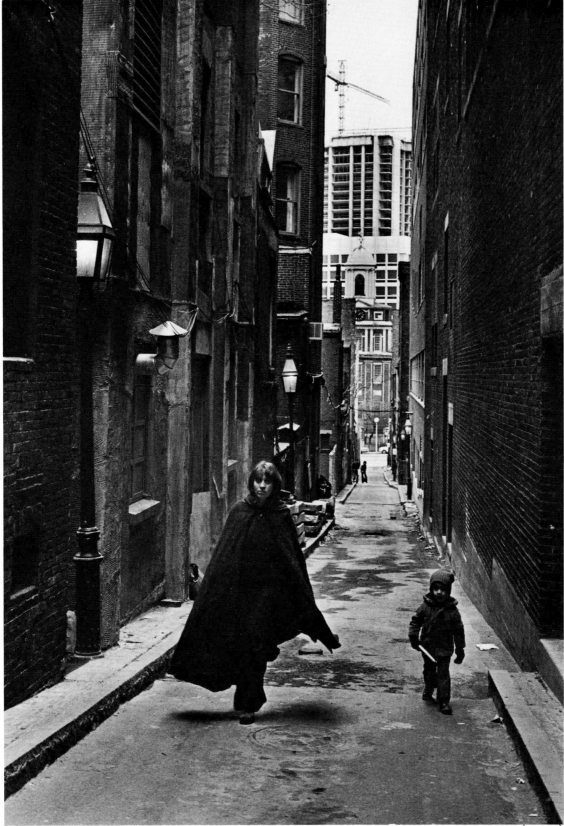

I felt for Paris that day, but I was sad, for the boy didn't carry an armful of bread. Beacon Hill (Boston)

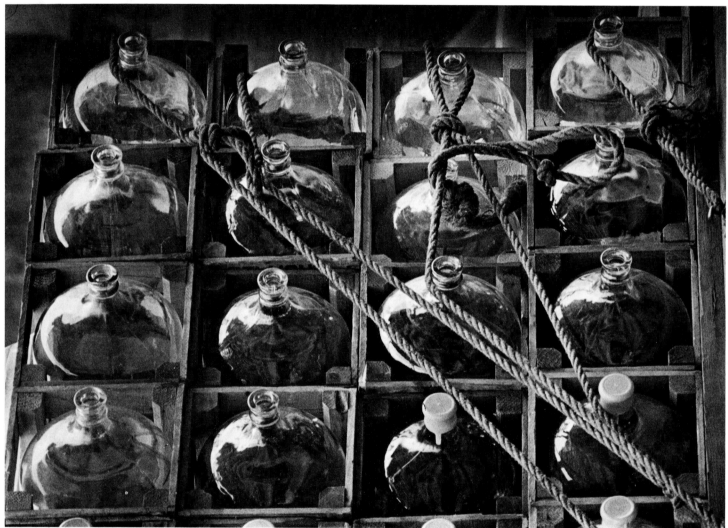

It was a difficult day; I couldn't find much in people . . . but the light on the bottles was so marvelous. Cambridge, Mass.

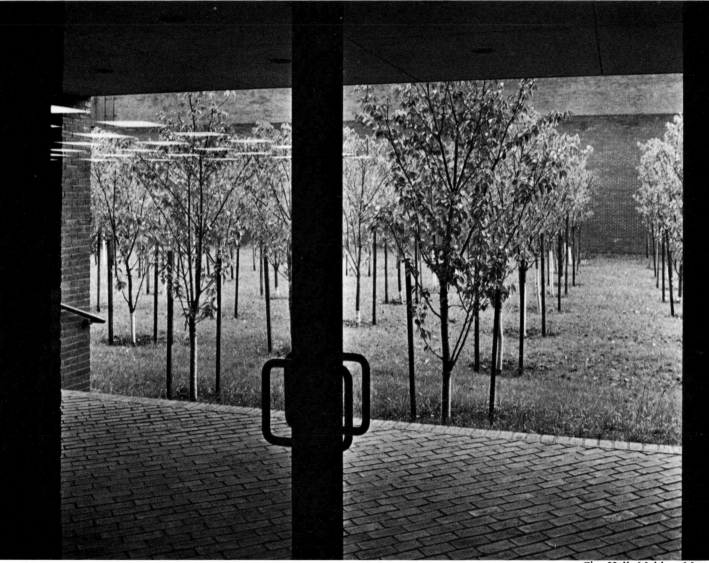

City Hall. Malden, Mass.

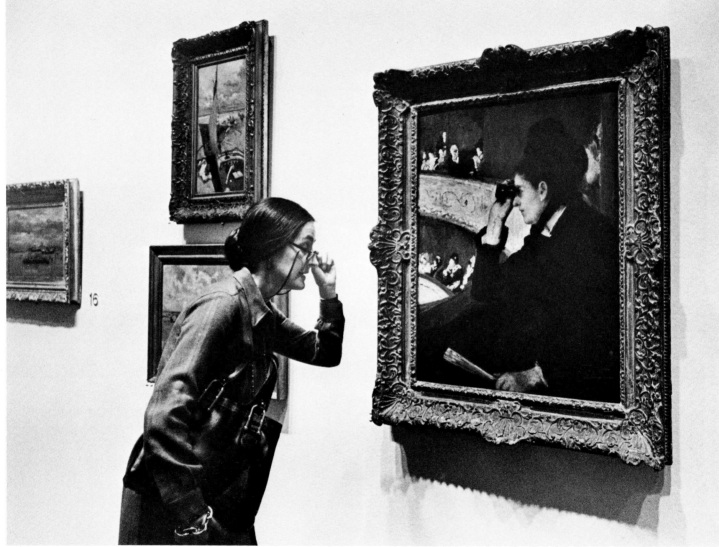

Museum of Fine Arts. Boston

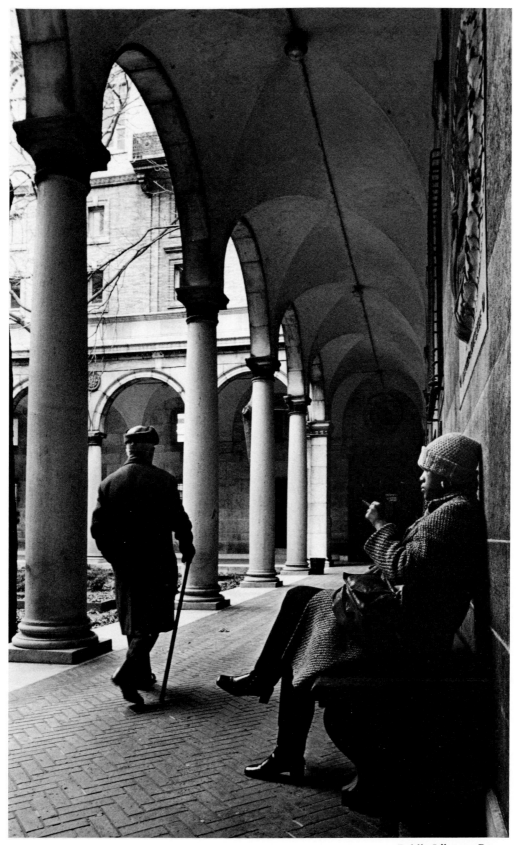

Public Library. Boston

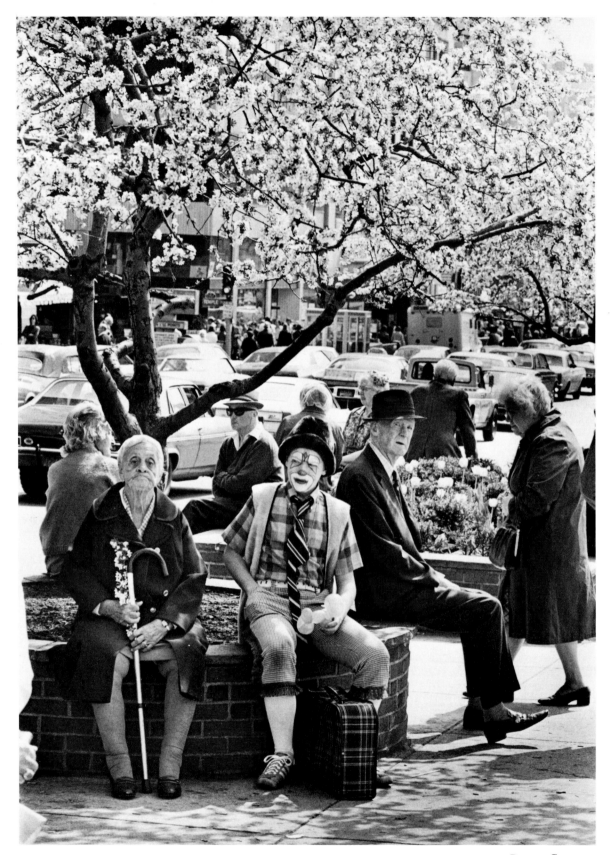

Boston Common

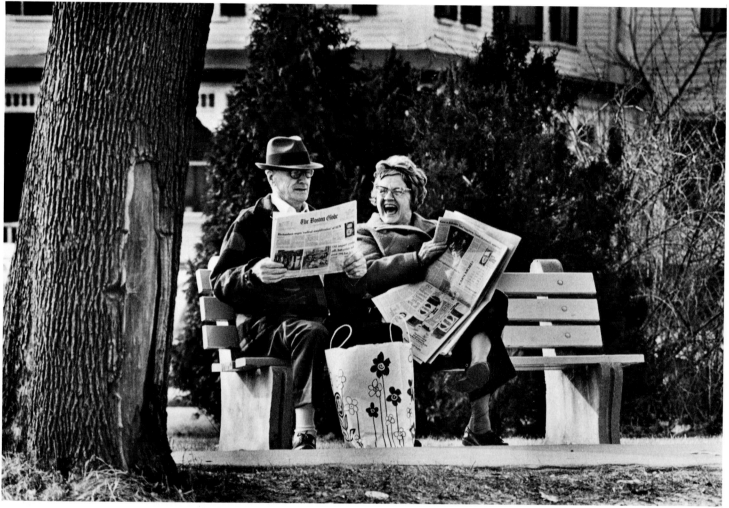

Some news is better read upside-down.

Stoughton, Mass.

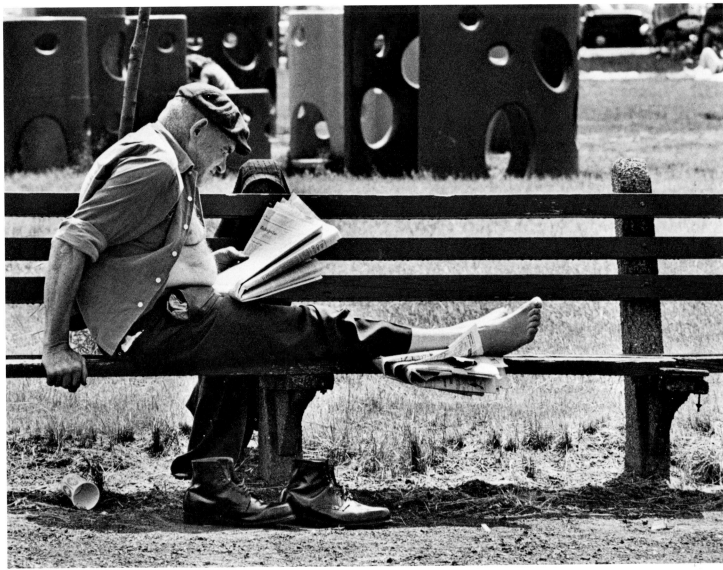

Boston

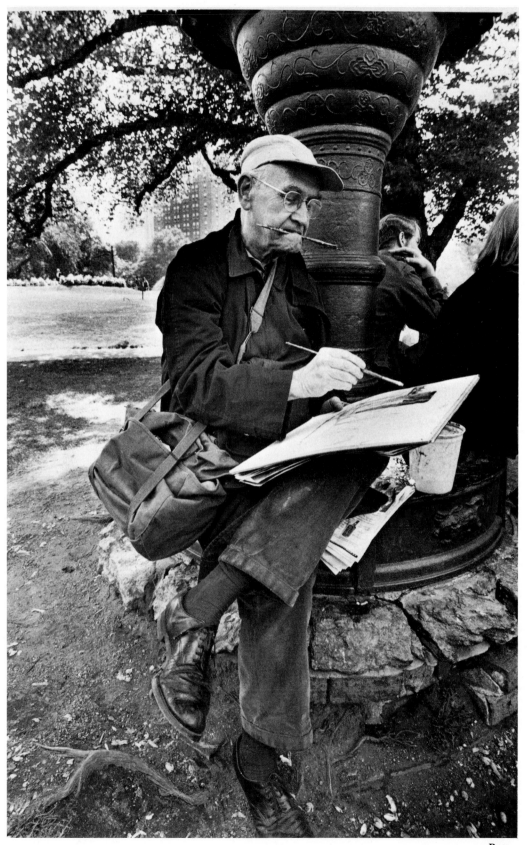

Boston

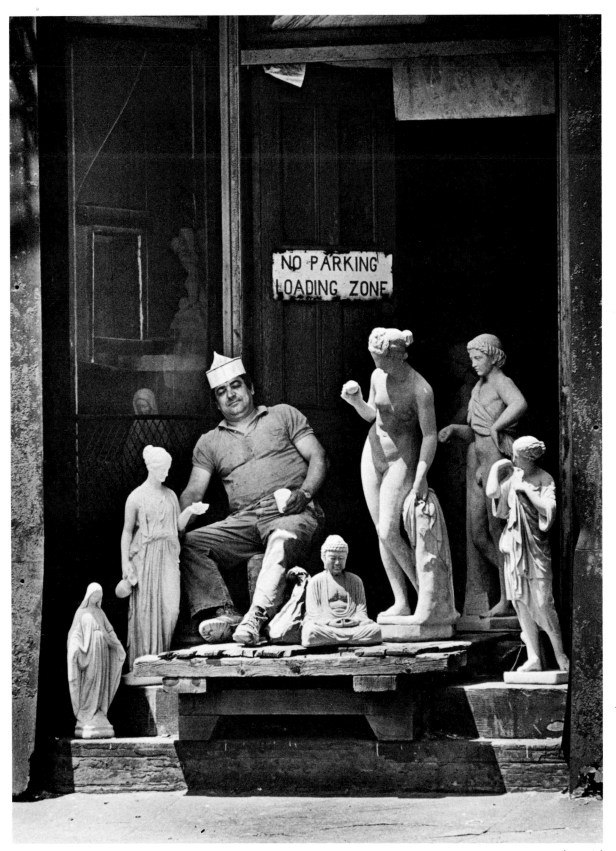

NO PARKING
LOADING ZONE

North End (Boston)

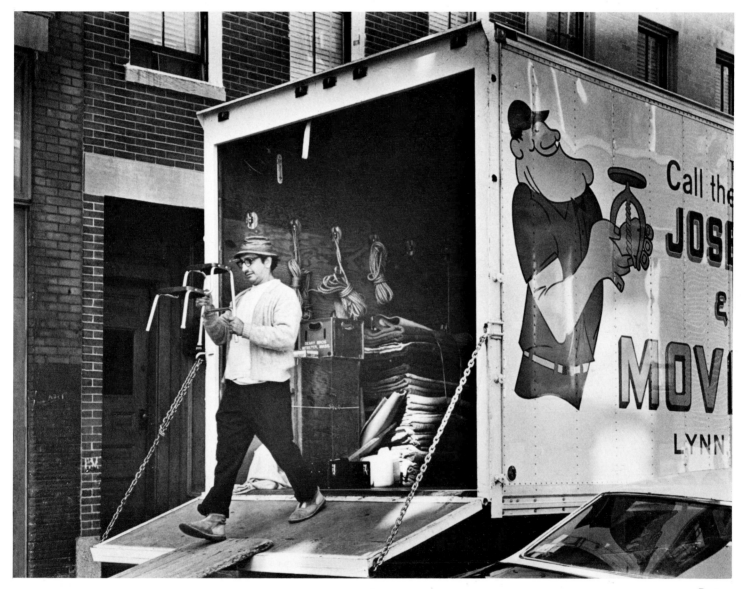

Boston

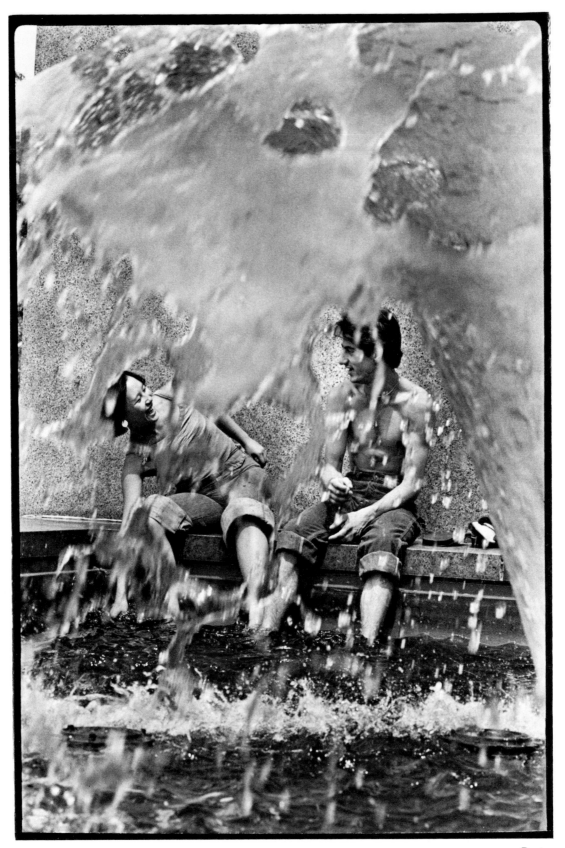

Boston

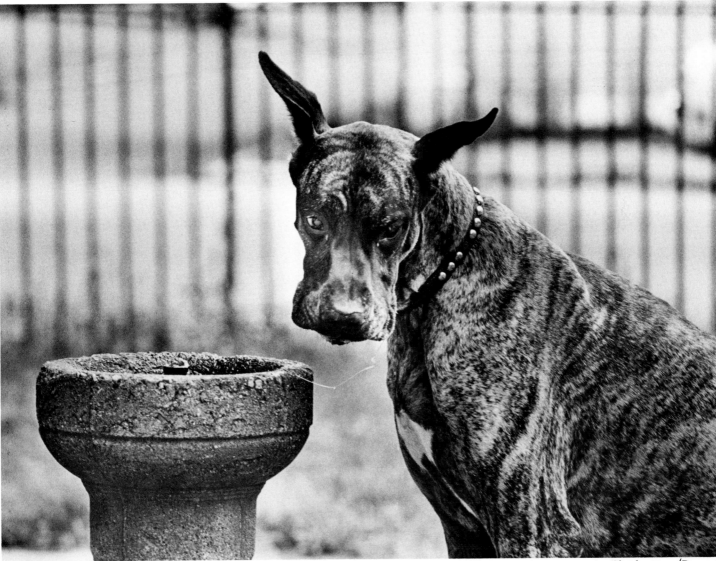

Charlestown (Boston)

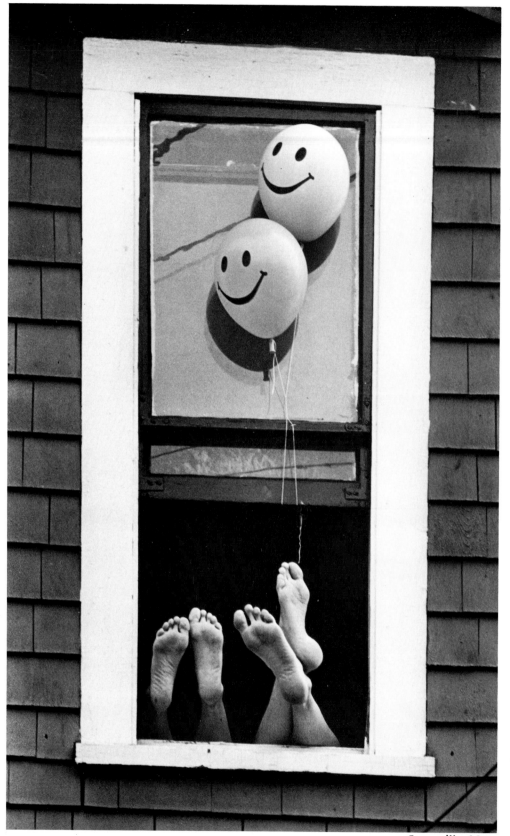

Somerville, Mass.

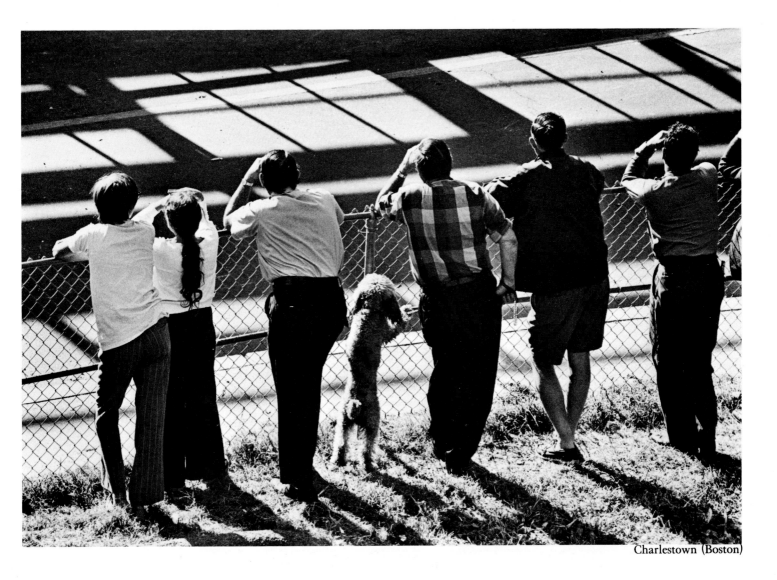

Charlestown (Boston)

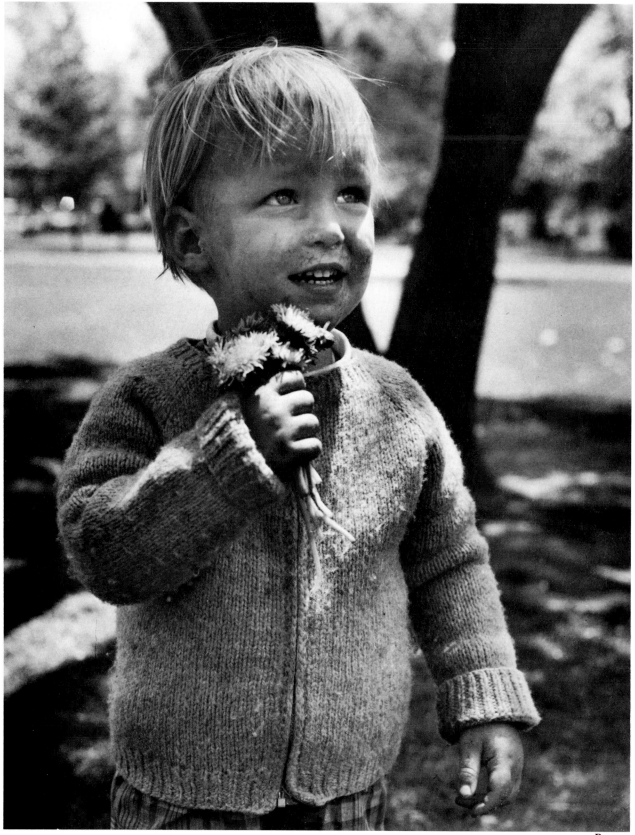

Boston

34

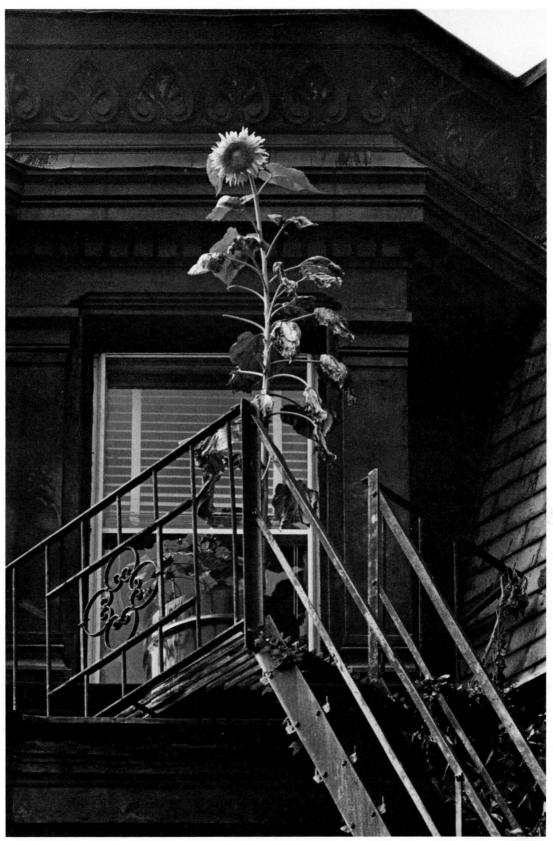

Boston

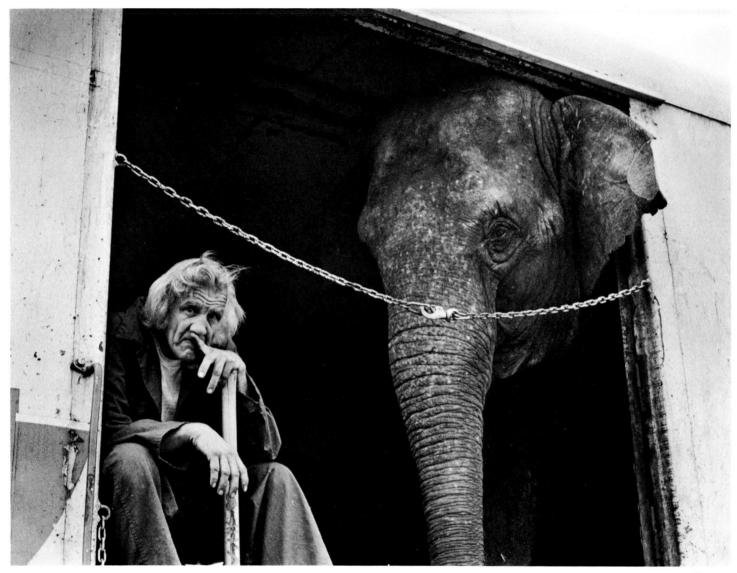

Boston

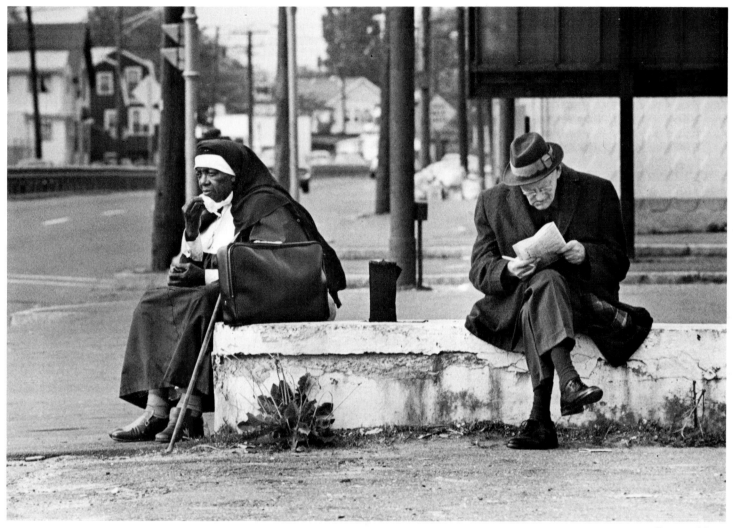

Revere, Mass.

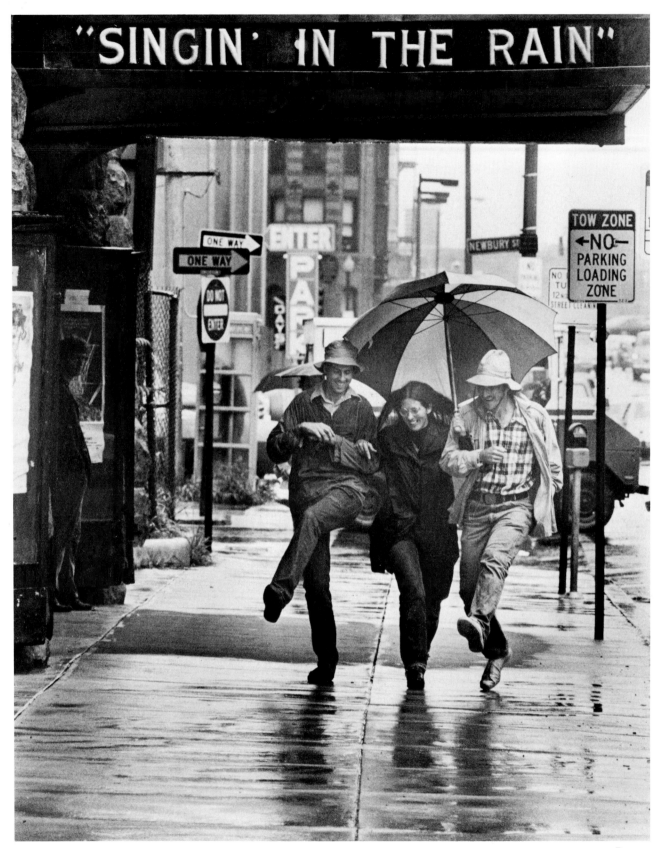

Boston

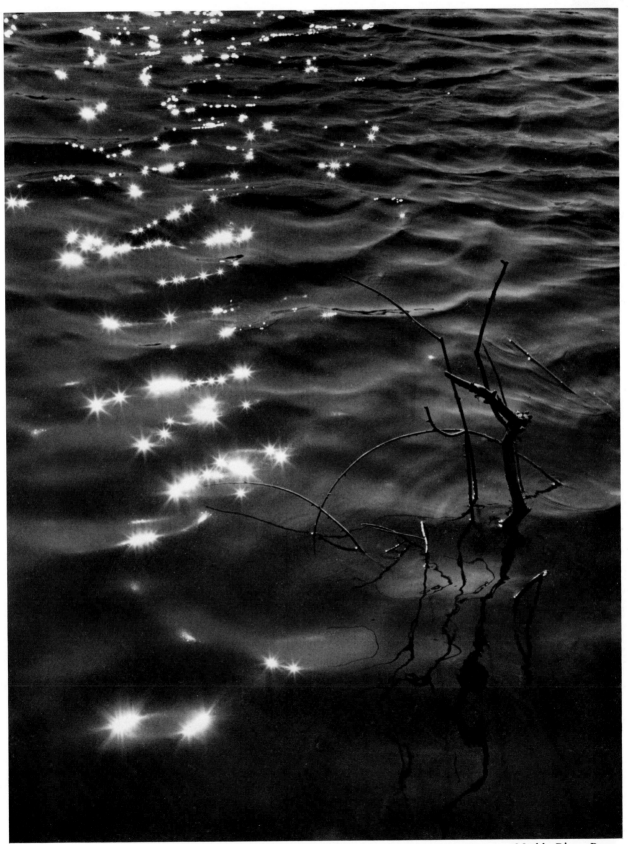

Muddy River. Boston

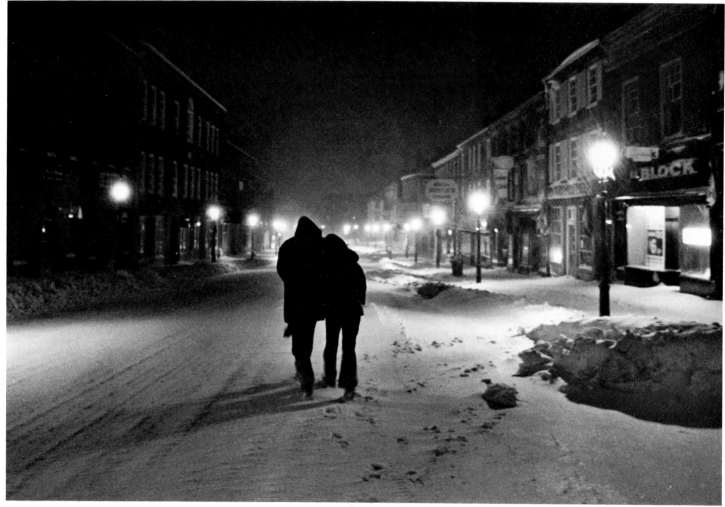

Newburyport, Mass.

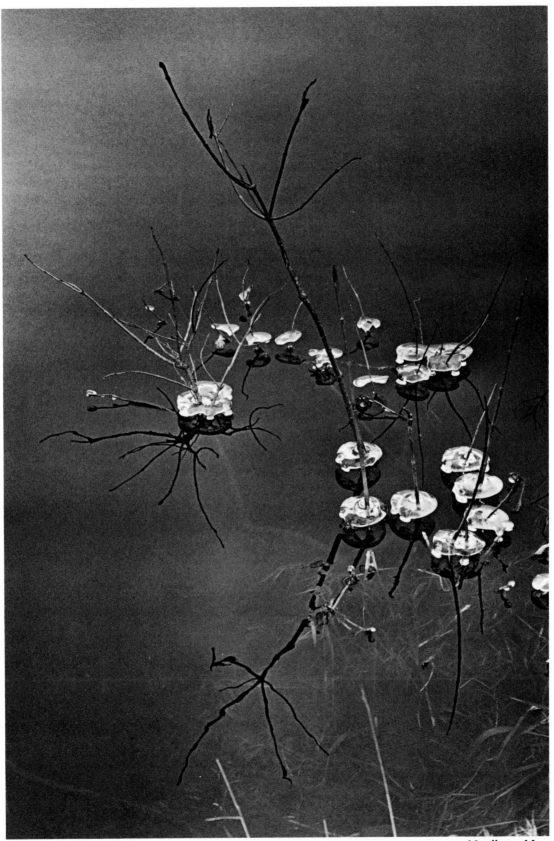

Needham, Mass.

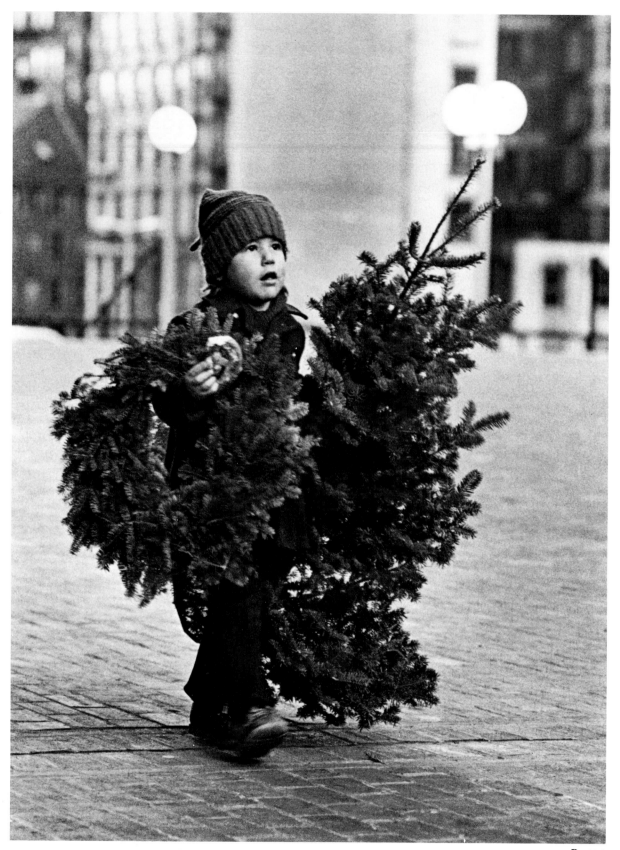

Boston

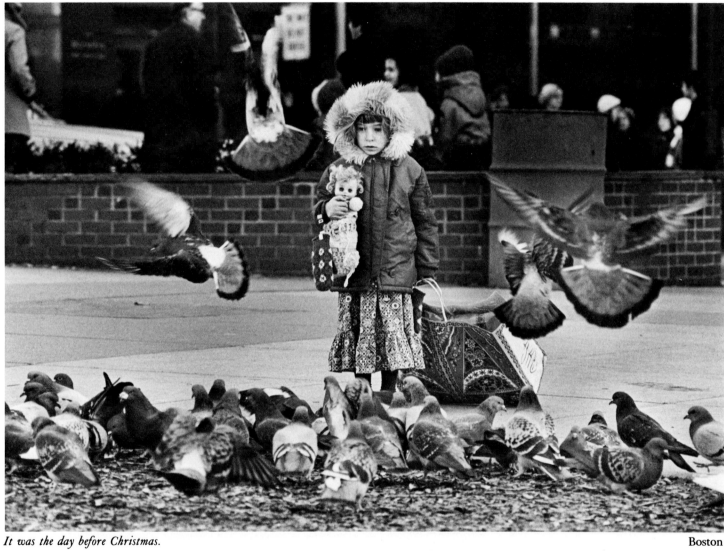

It was the day before Christmas. Boston

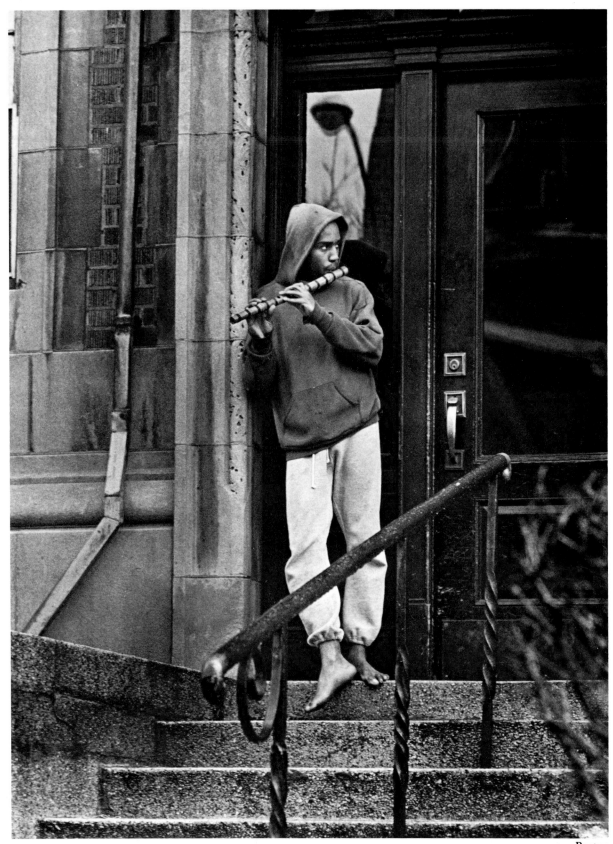

Boston

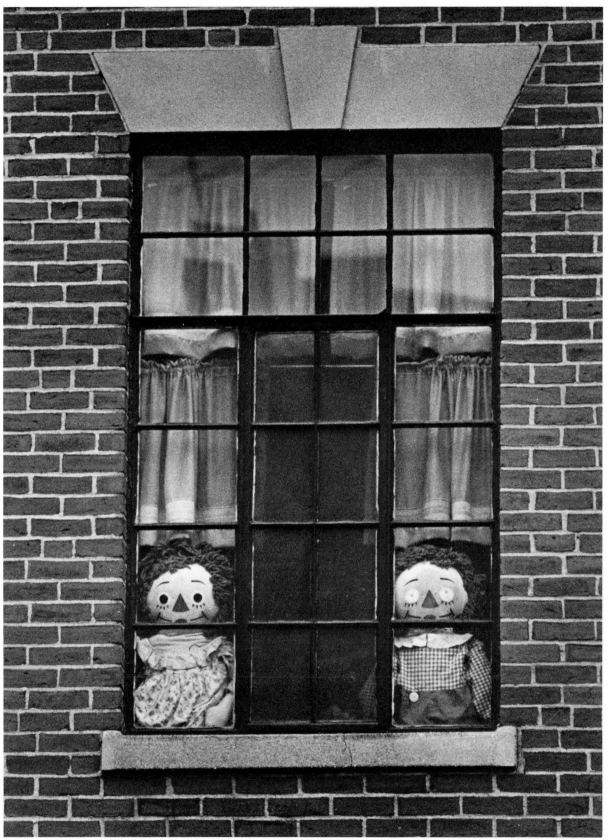

Boston

I love to sniff country air . . . so full of fresh hay, apples and barnyards. The people's outlook is so healthy.

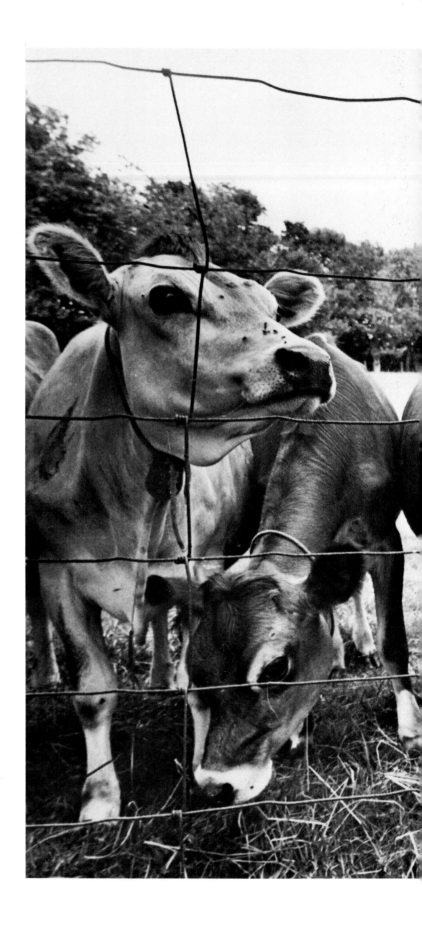

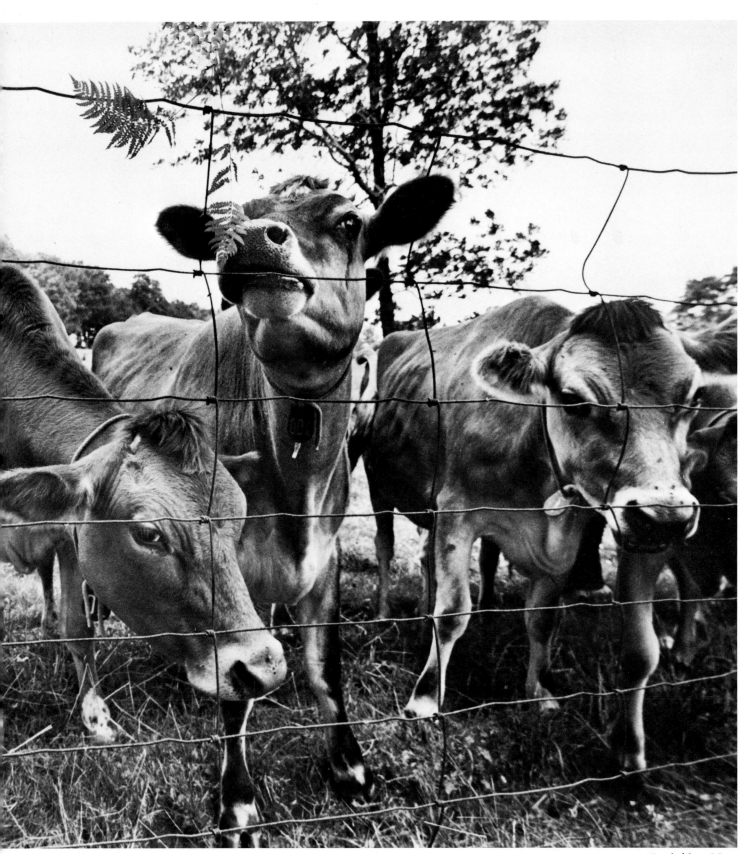

Sturbridge, Mass.

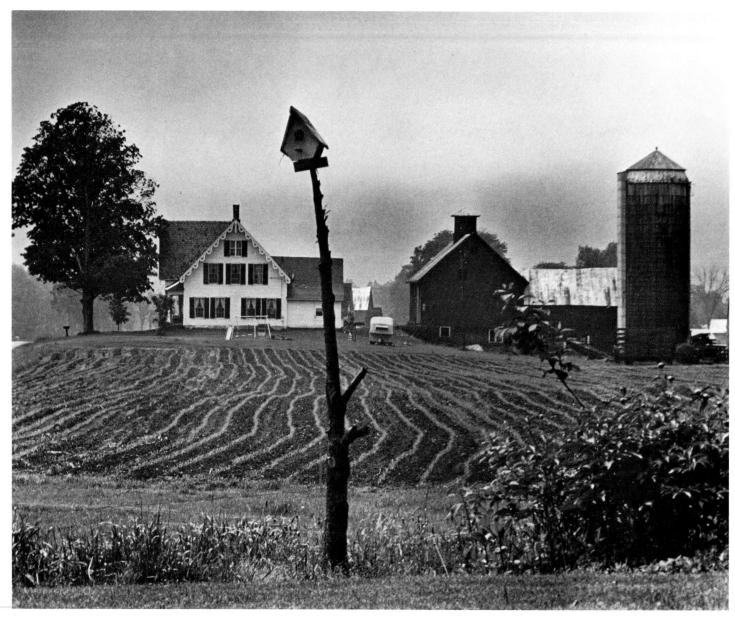

East Brookfield, Vt.

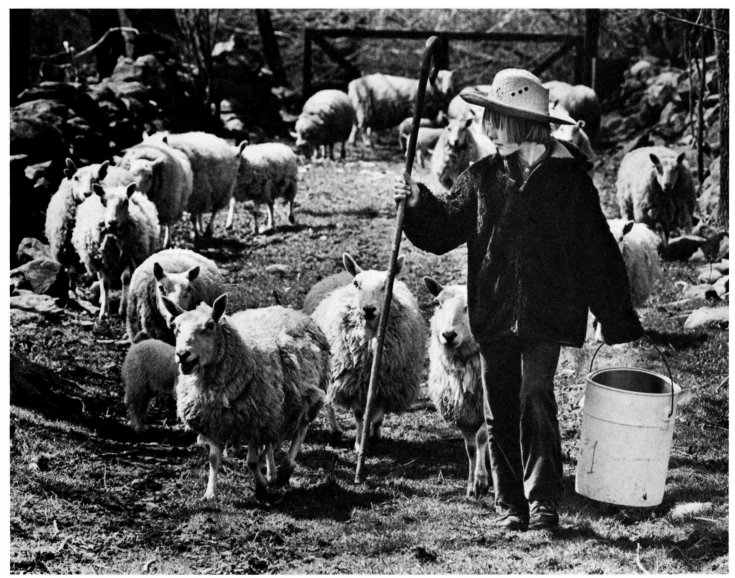

It was Palm Sunday and I searched for sheep. When I found them, the farmer had a son, and I my shepherd. Sherborn, Mass.

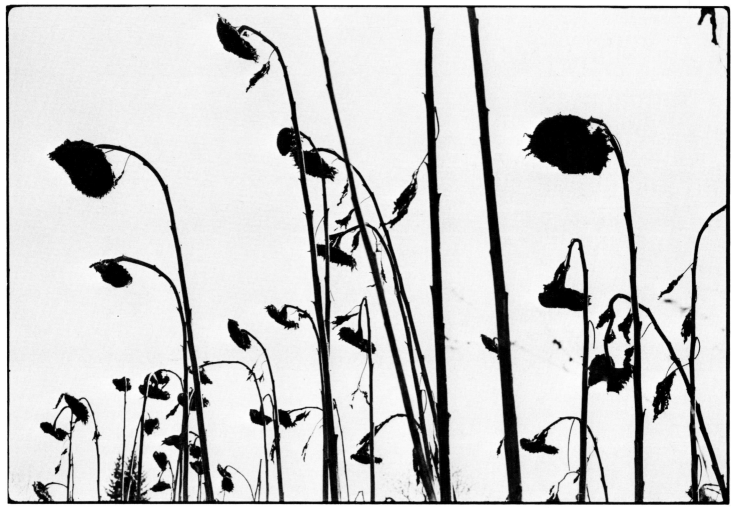

Lincoln, Mass.

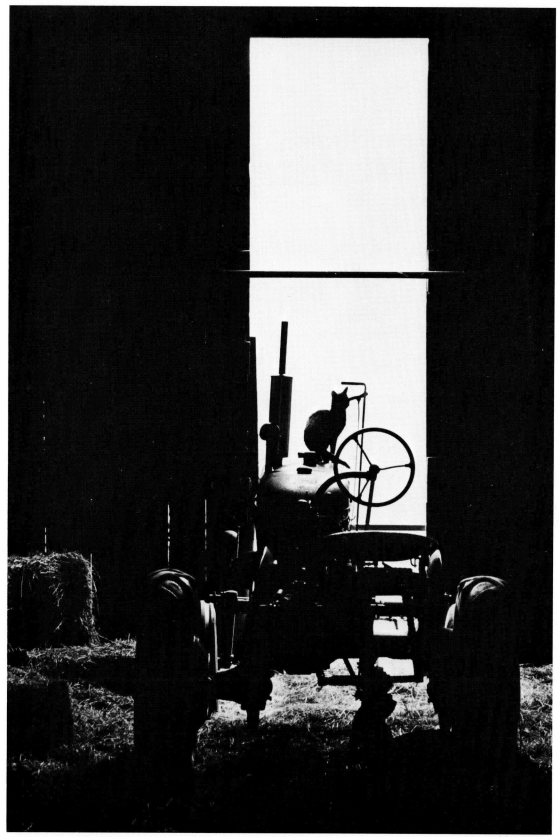

Dunstable, Mass.

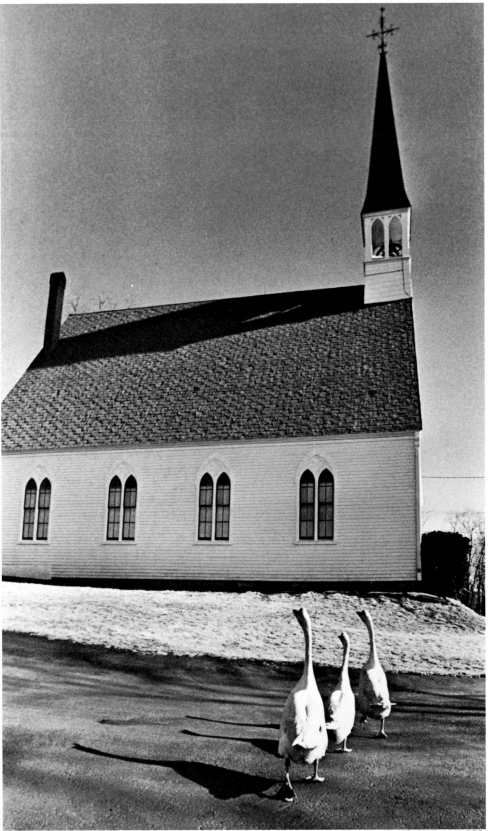

South Weare, N.H.

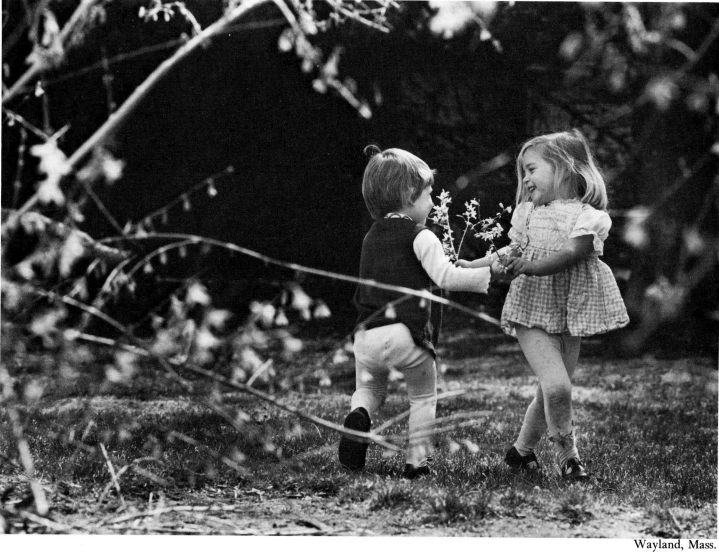

Wayland, Mass.

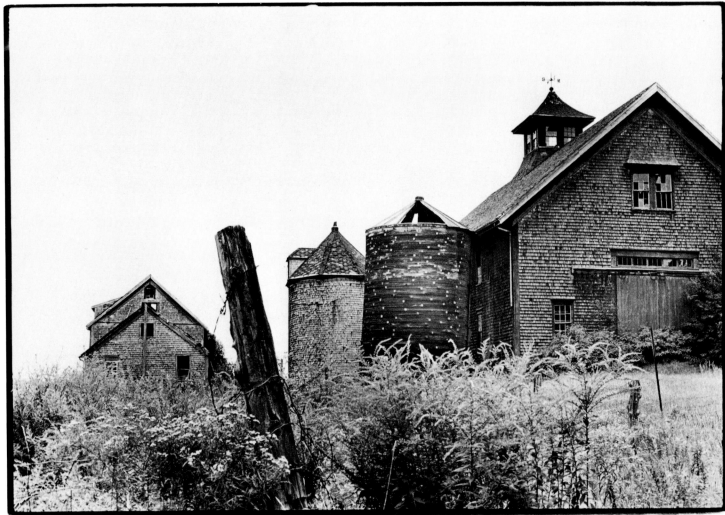

Hingham, Mass.

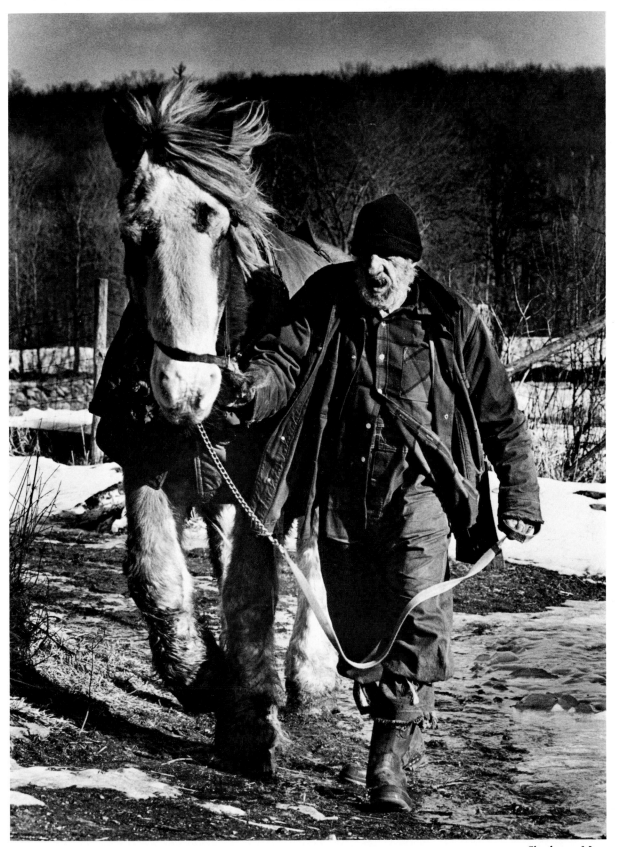

Sherborn, Mass.

I was attracted by sheep, and white smoke from a barn chimney. It was in 1973-74 during the energy crisis, and the family had moved into the barn to celebrate Christmas. Everything was dressed up a little — simple, but with the smell of pine and warmth from a woodstove, which in other years kept the chickens warm. I loved the feeling of rest which was about the old gentleman.

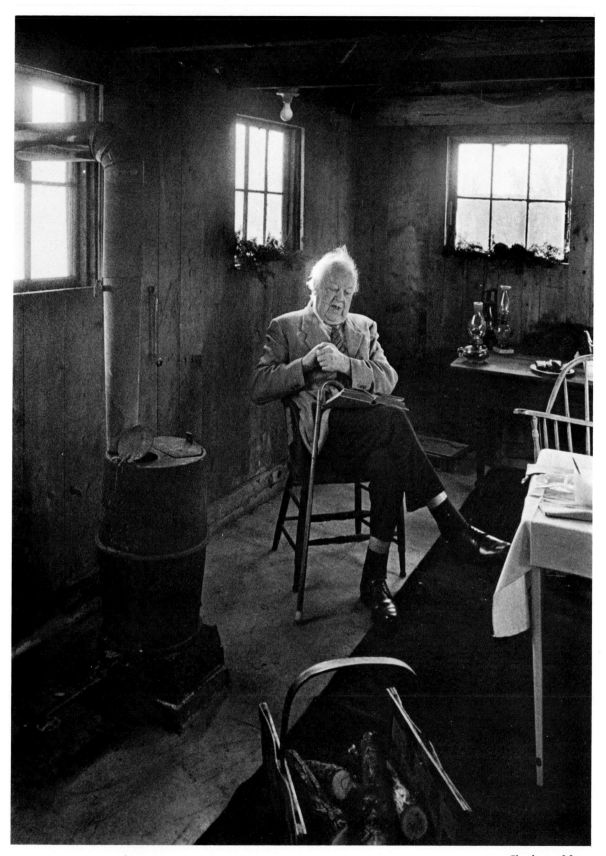

Sherborn, Mass.

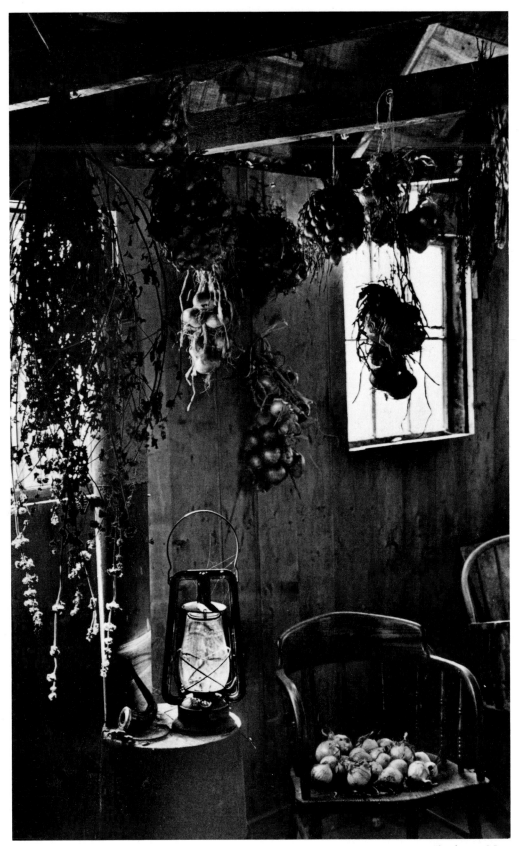

Sherborn, Mass.

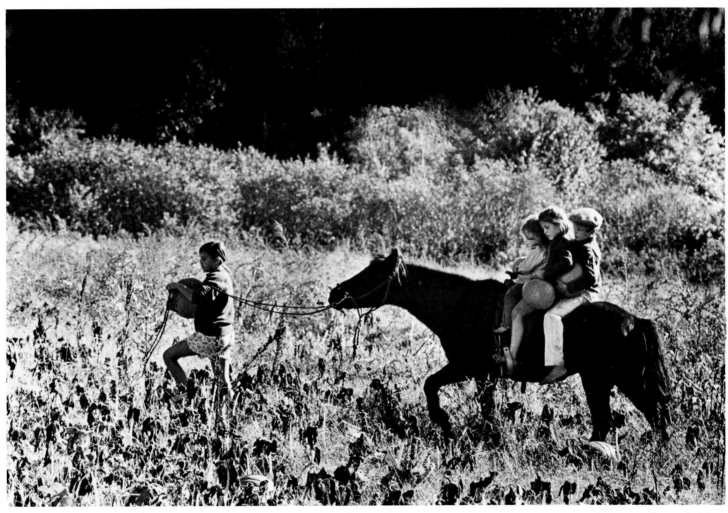

Concord, Mass.

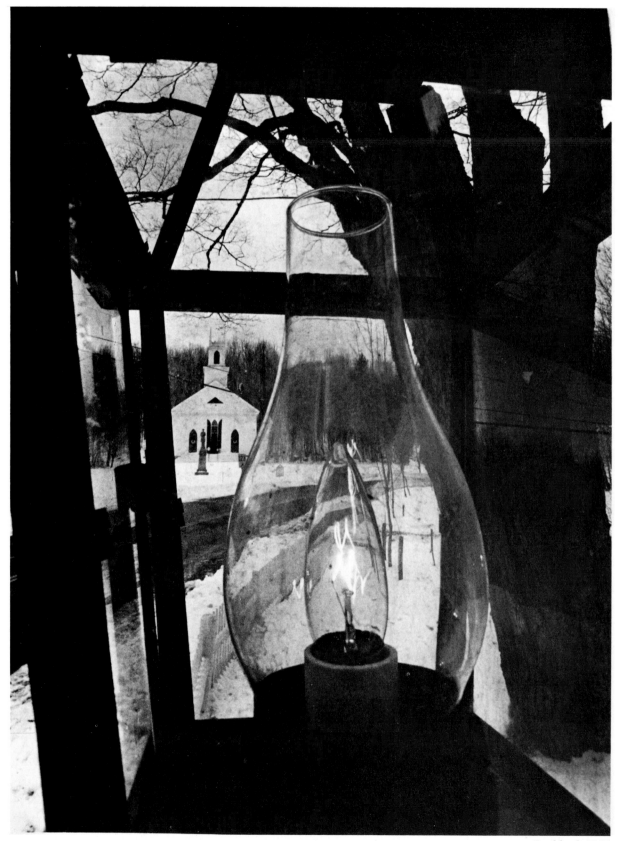

Stoddard, N.H.

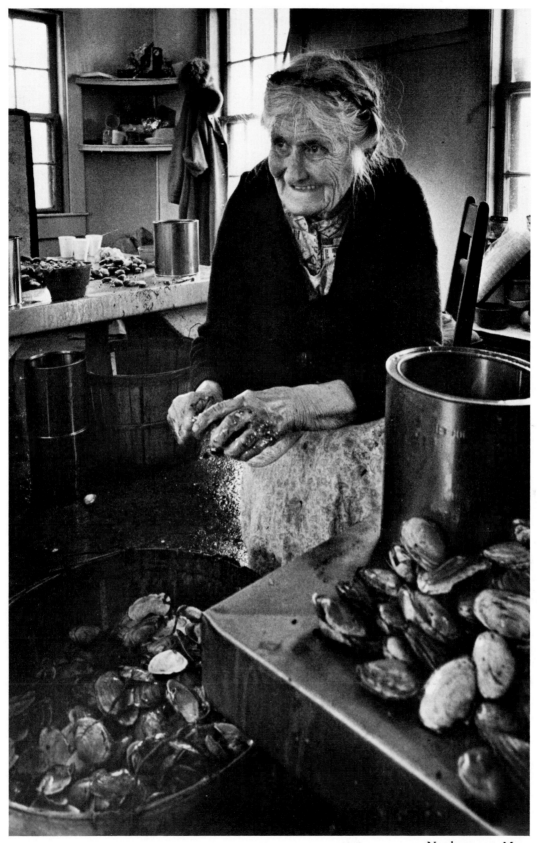

Newburyport, Mass.

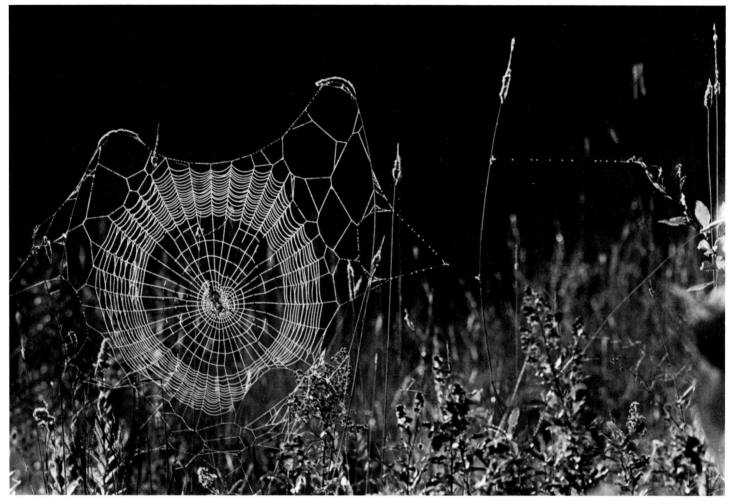

Goffstown, N.H.

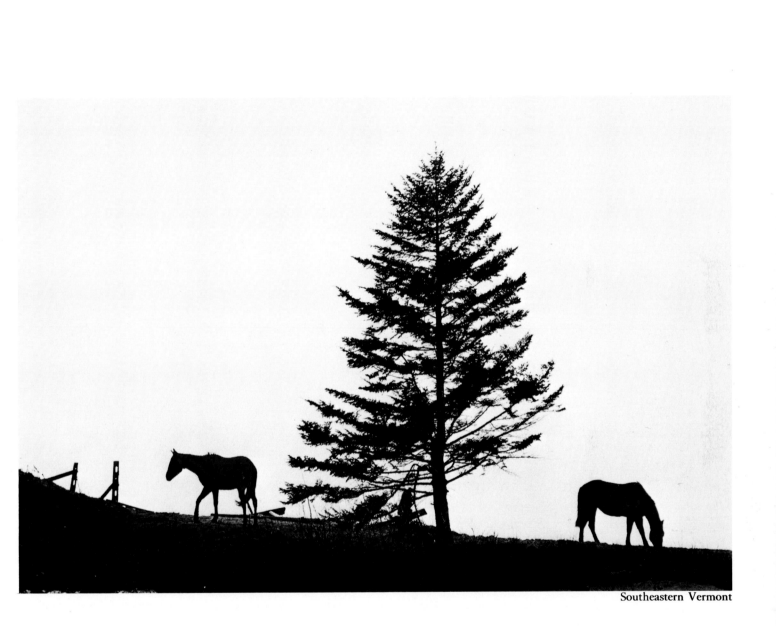

Southeastern Vermont

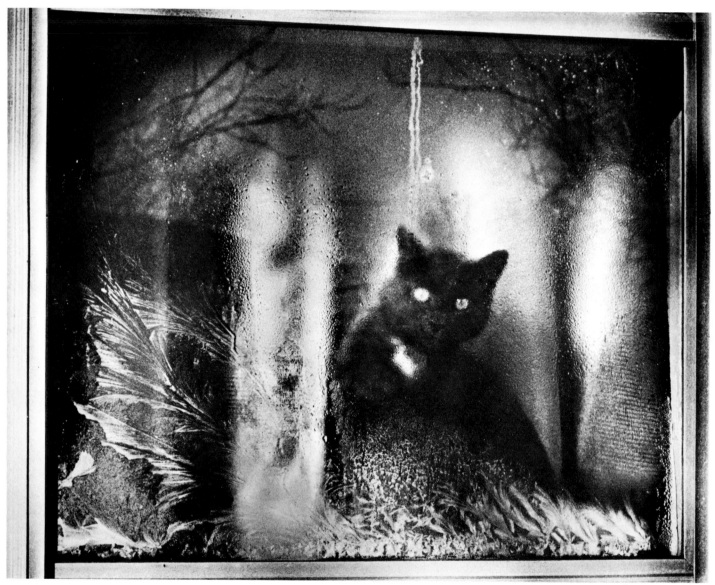

Squantum, Mass.

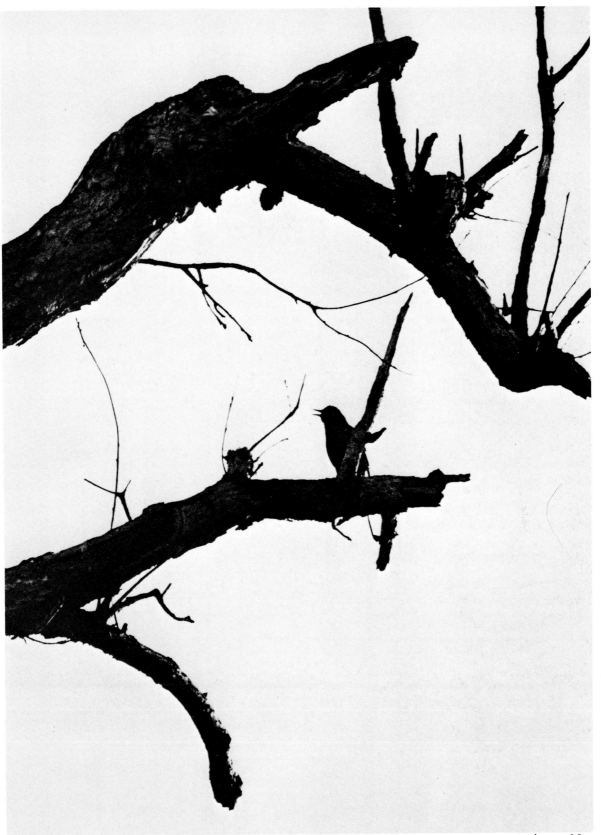

Braintree, Mass.

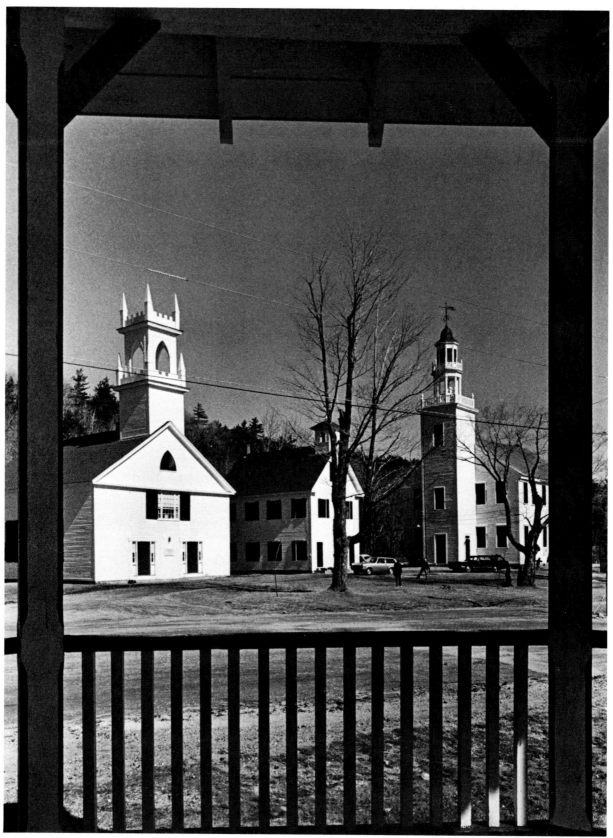

Washington, N.H.

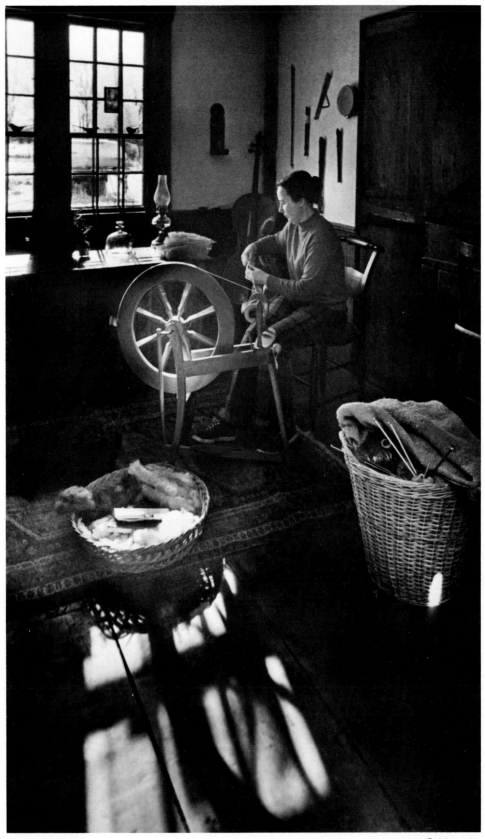

Deerfield, N.H.

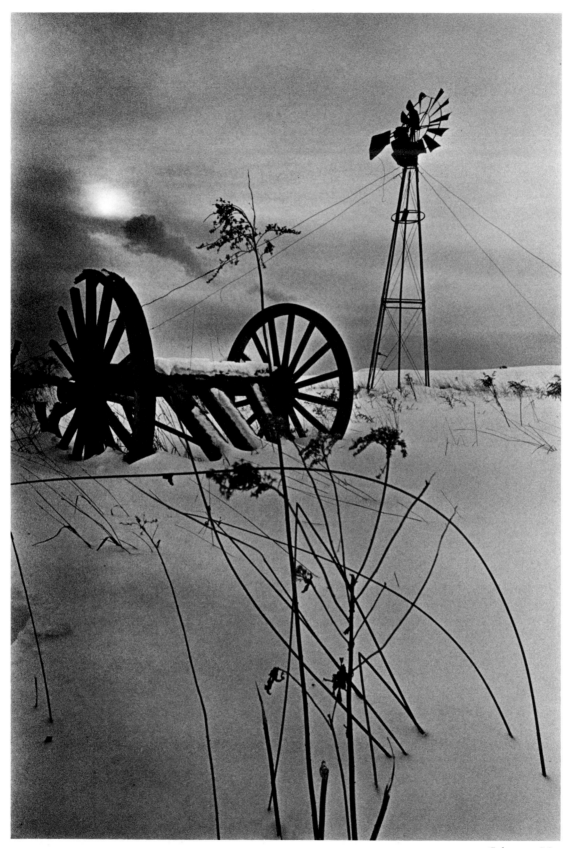

Sabattus, Me.

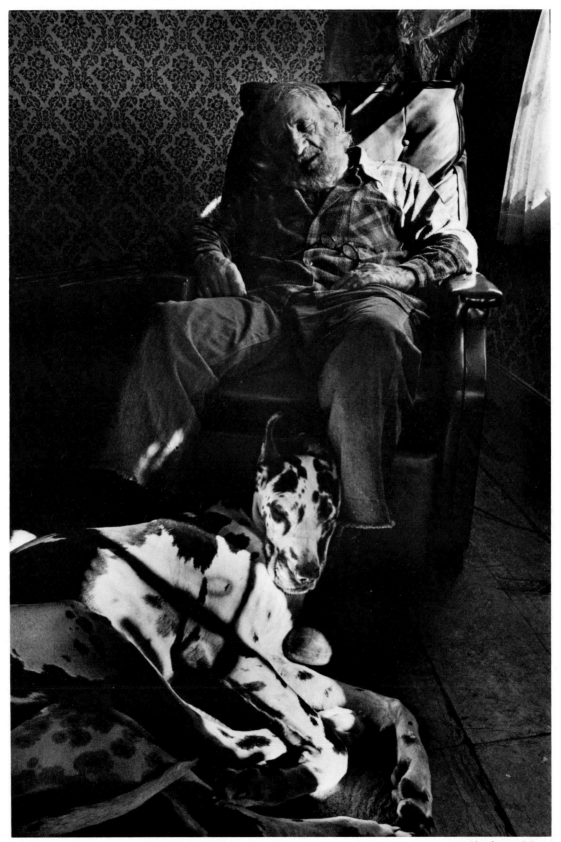

Sherborn, Mass.

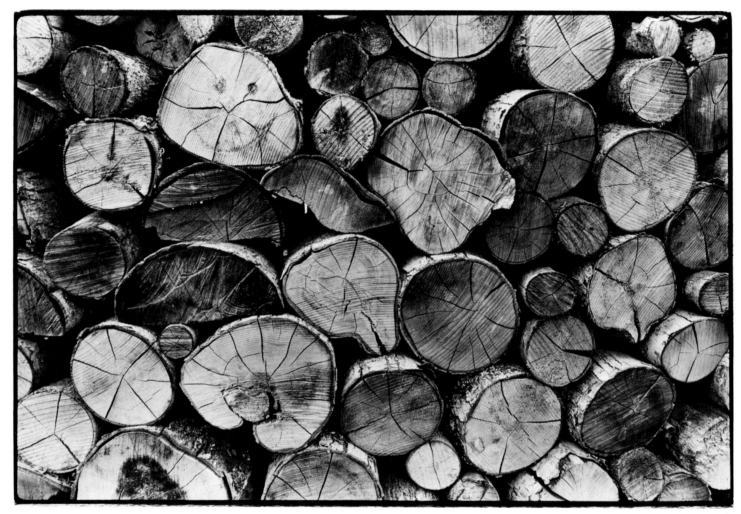

Canterbury, N.H.

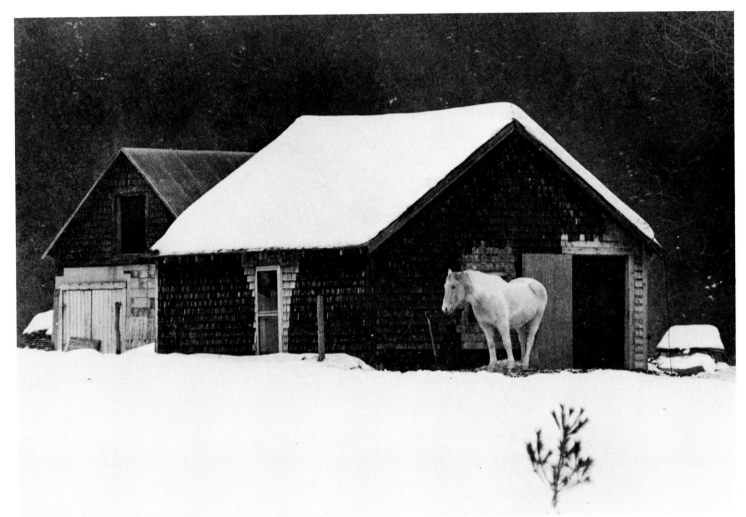

Dixville Notch, N.H.

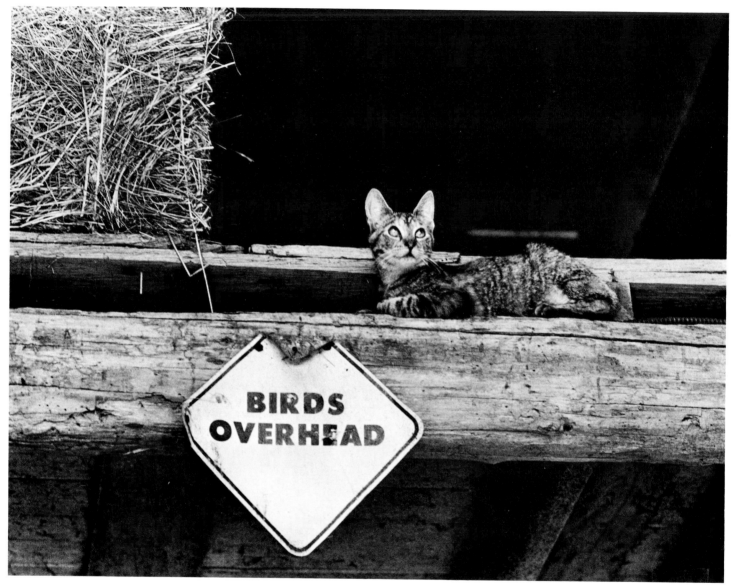

Sherborn, Mass.

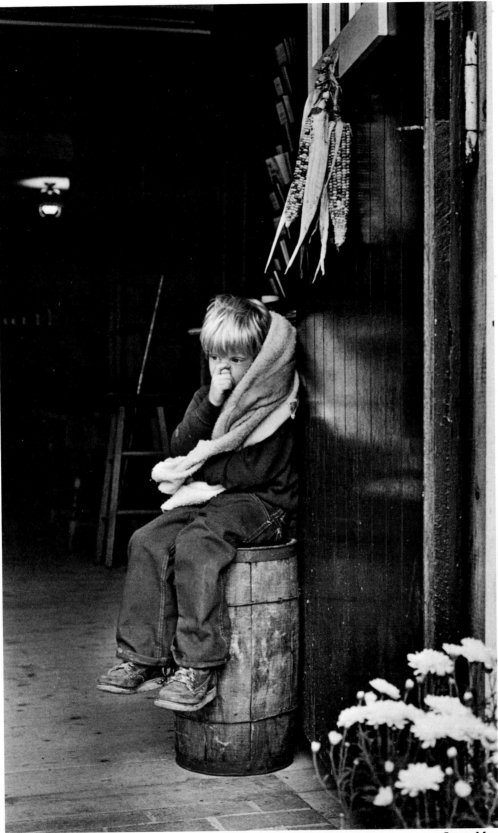

Stow, Mass.

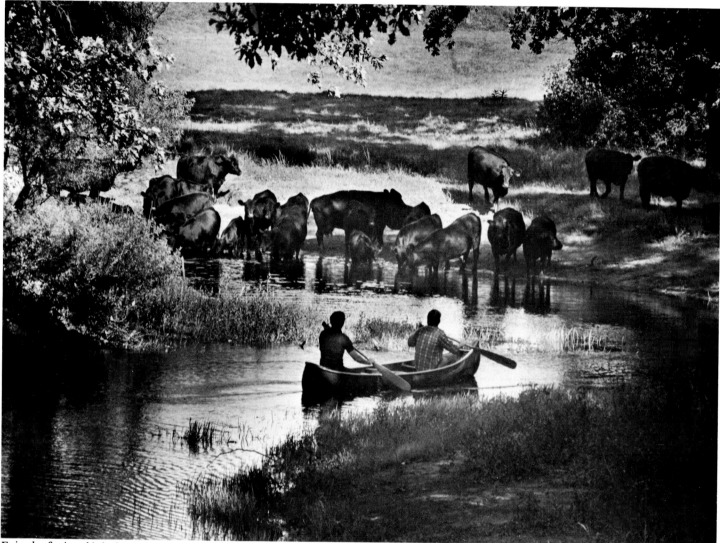

Friends of mine think this is Kenya.

Topsfield, Mass.

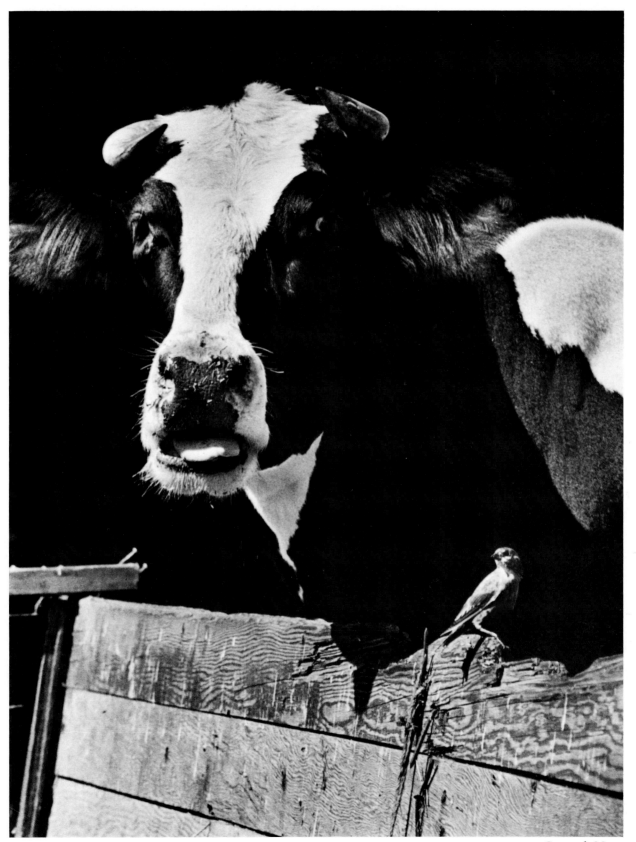

Concord, Mass.

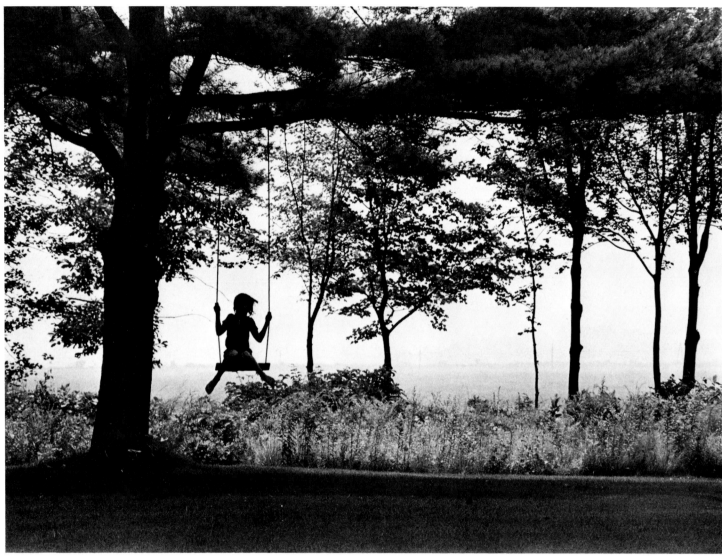

Hampton, N.H.

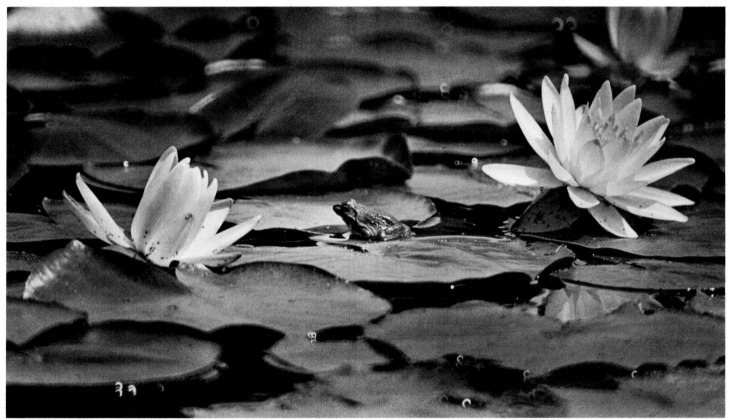

The kindest frog I ever knew. He waited. Boxford, Mass.

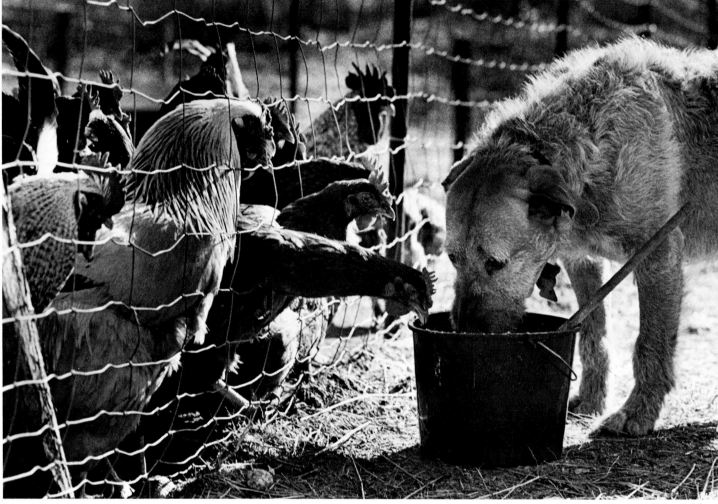

Carver, Mass.

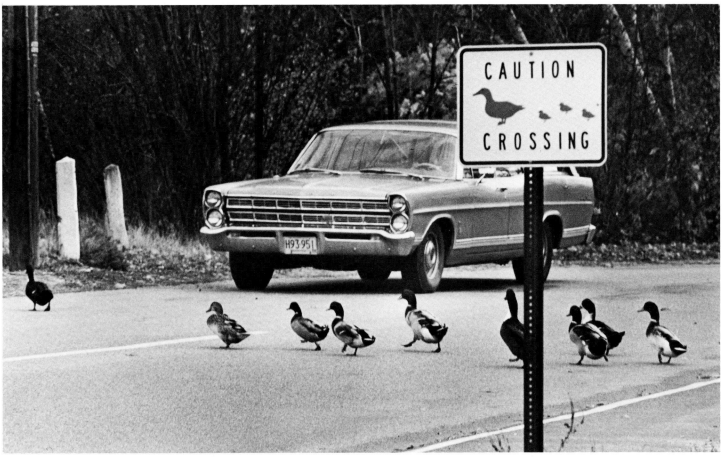

Kingston, Mass.

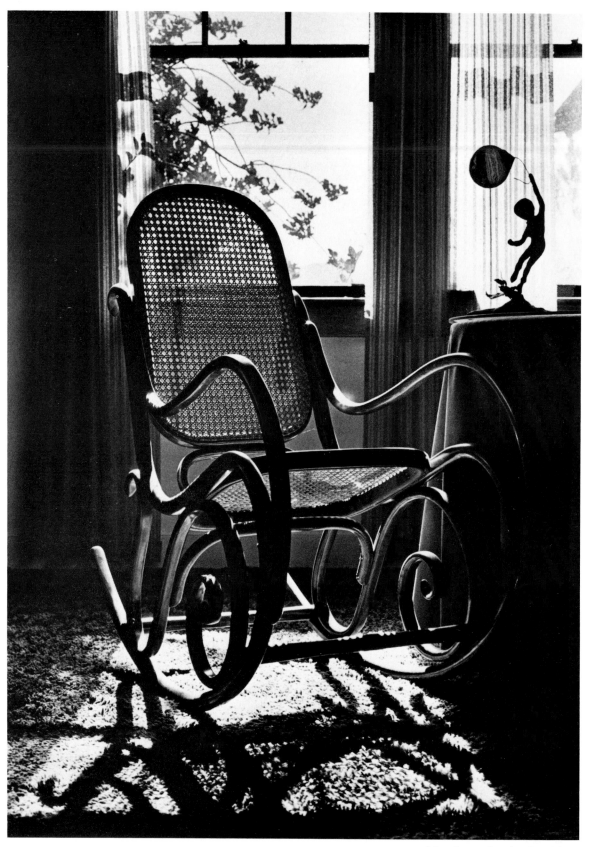

Manchester by the Sea, Mass.

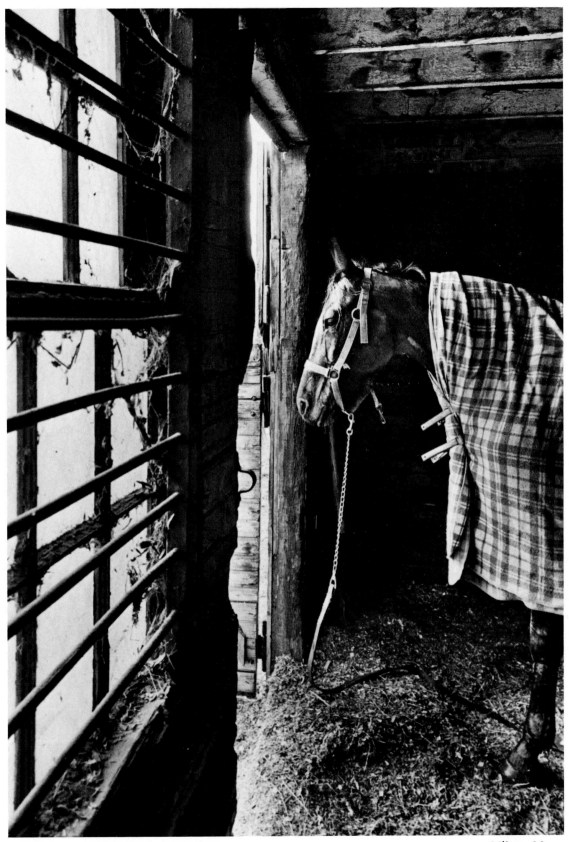

Milton, Mass.

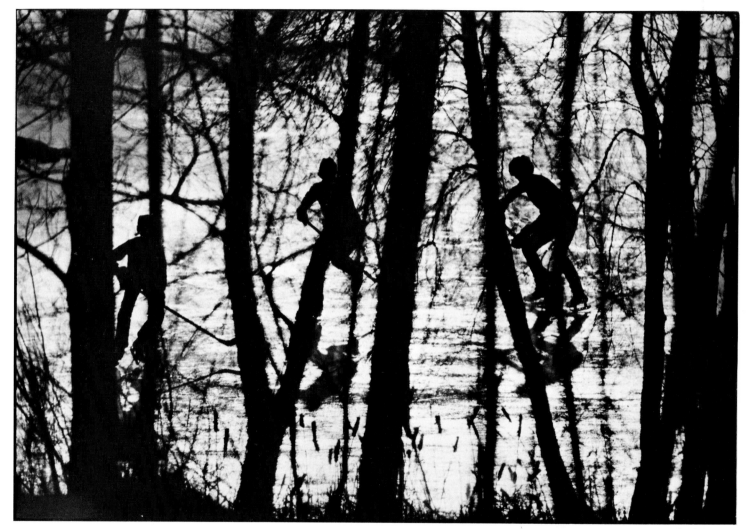

Walpole, Mass.

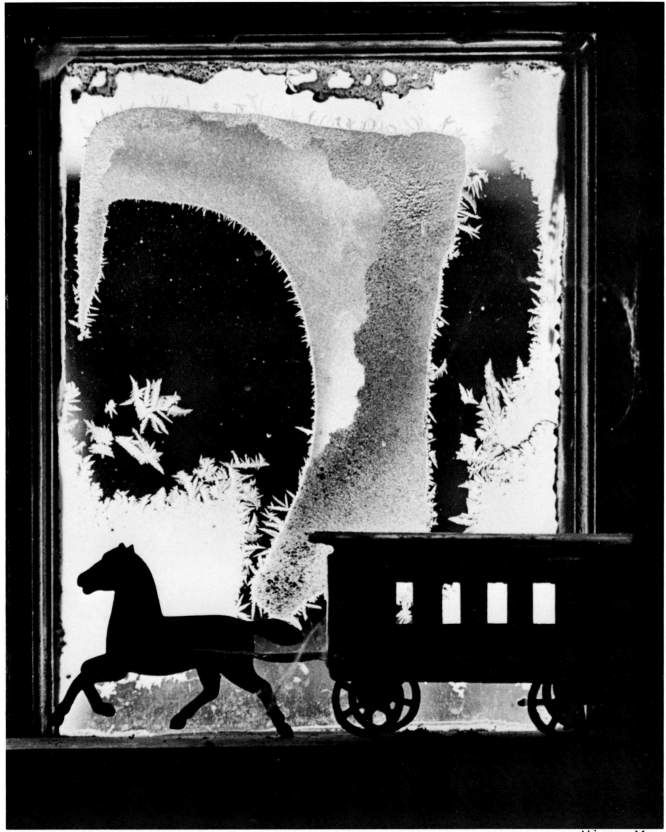

Abington, Mass.

My sea connects us all.
I think that's why I
feel so free in and
near it.

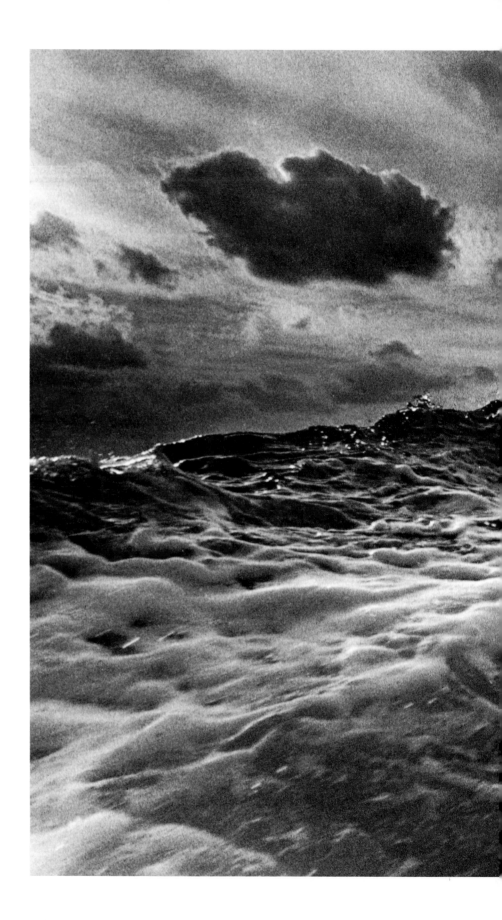

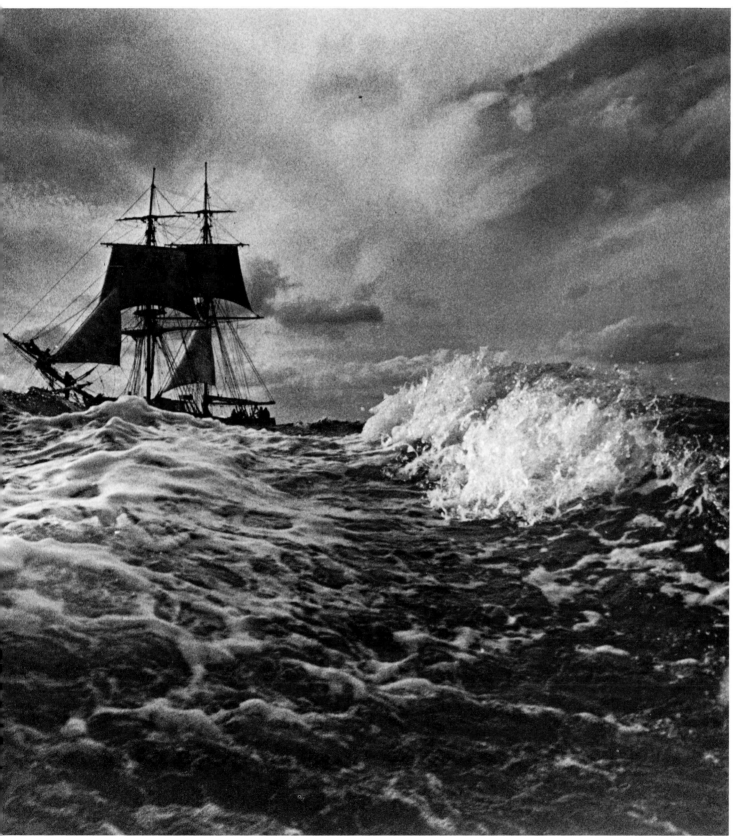

"Beaver II" — The Boston Tea Party ship. Off Martha's Vineyard

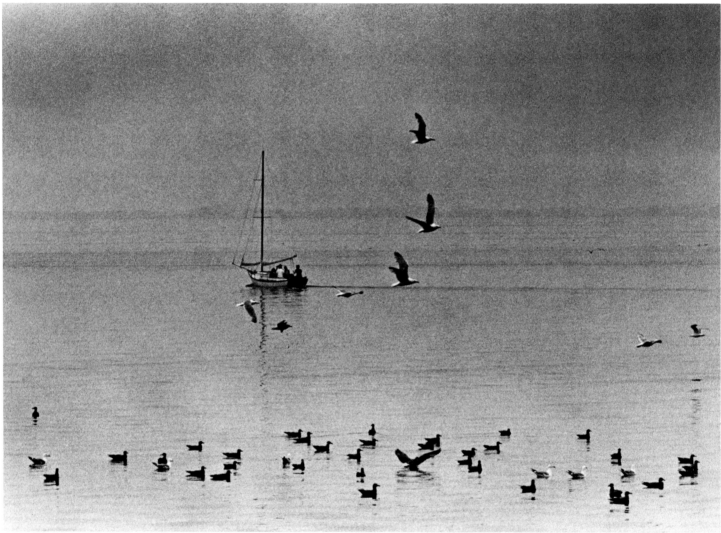

Off Plymouth, Mass.

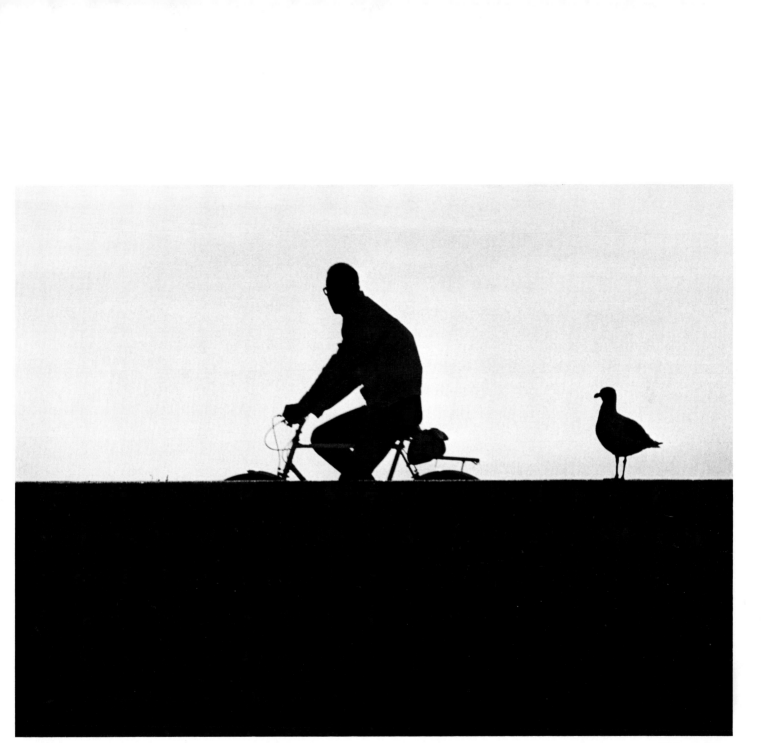

Nahant, Mass.

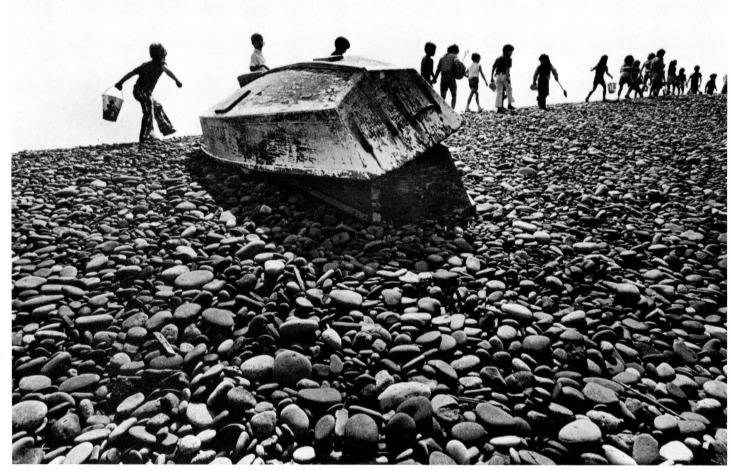

Scituate, Mass.

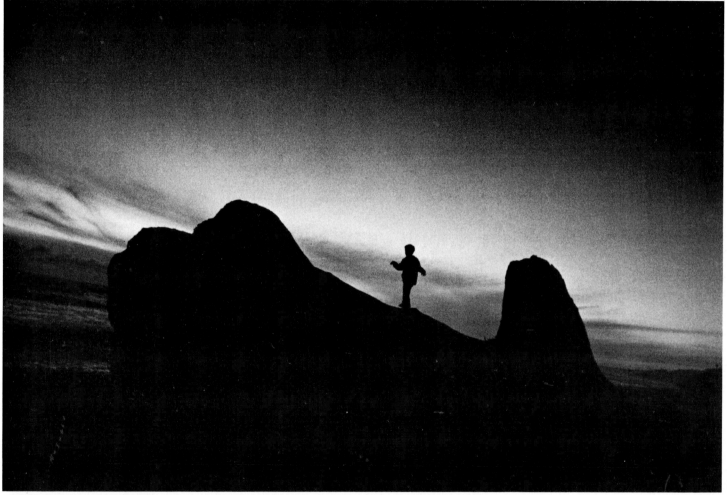

Casco Bay, Me.

Majestic above, open and wide
calmly below the leaving tide;
wondering what is beyond the height,
wondering if we have the right
to ask what is beyond.

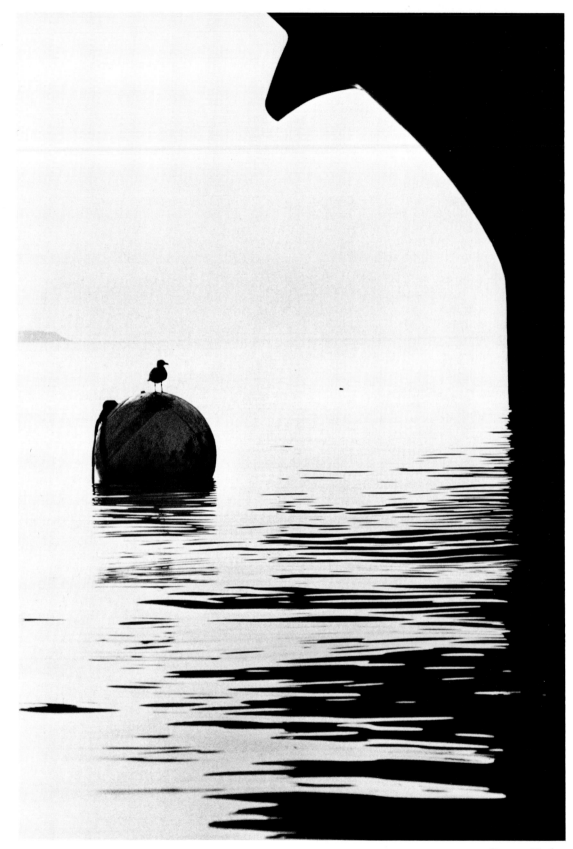

Boston Harbor

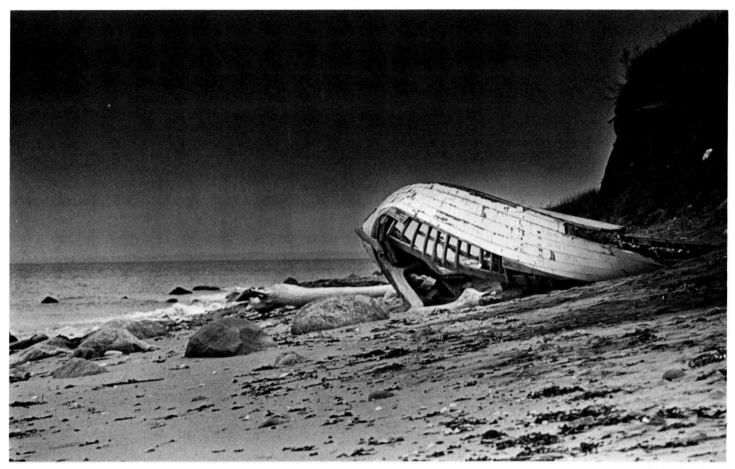

Block Island, R.I.

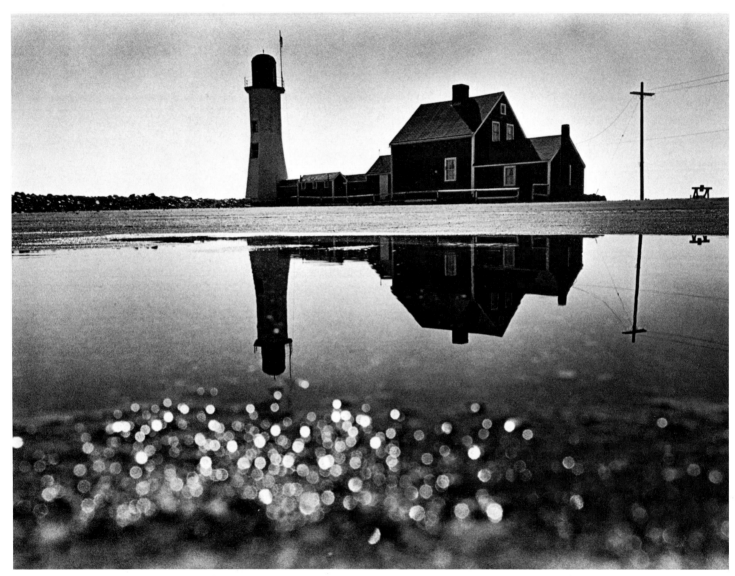

I looked everywhere for framing for this pretty lighthouse; eventually I spotted a small puddle in the parking lot and lay on the ground to catch the reflection.

Scituate, Mass.

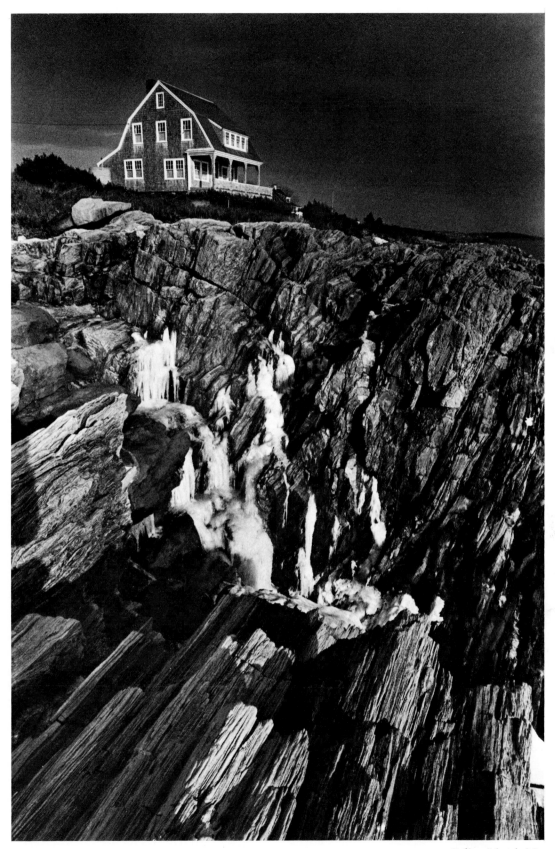

Bailey Island, Me.

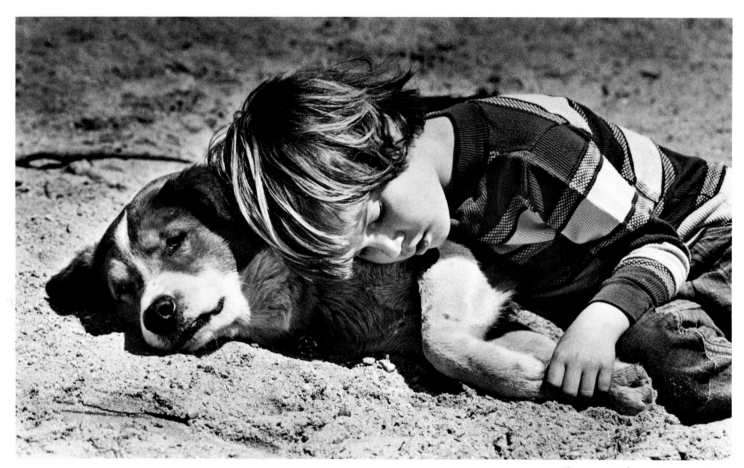

Indian Head River. Hanover, Mass.

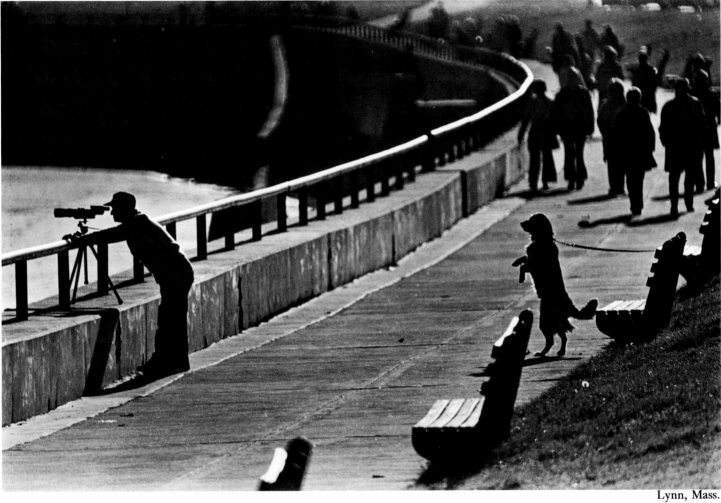

Lynn, Mass.

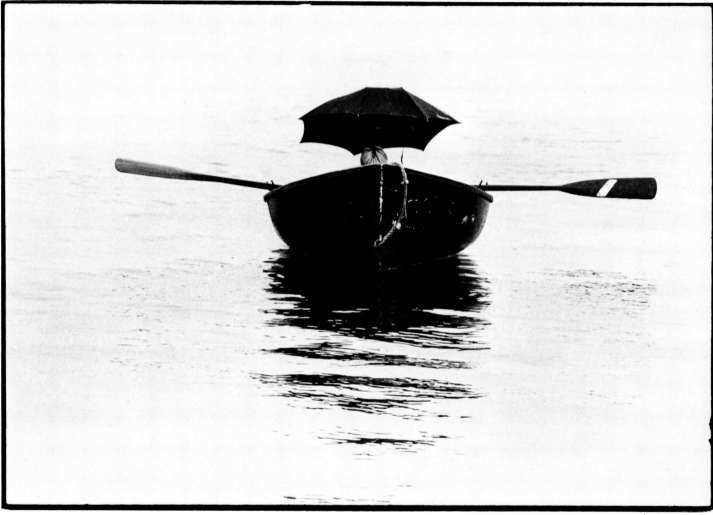

Winthrop, Mass.

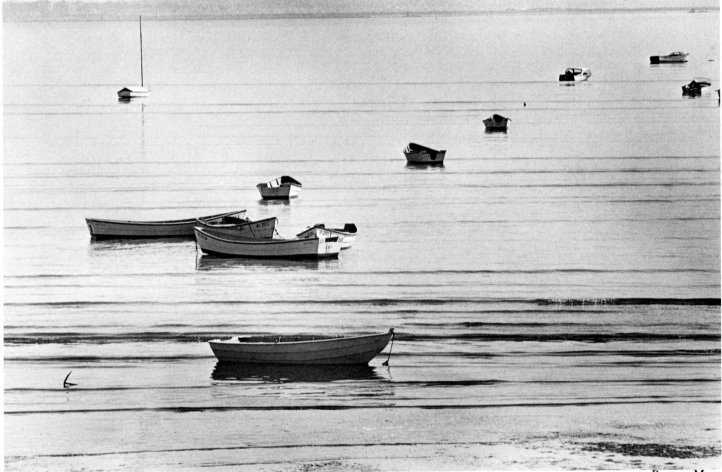

Revere, Mass.

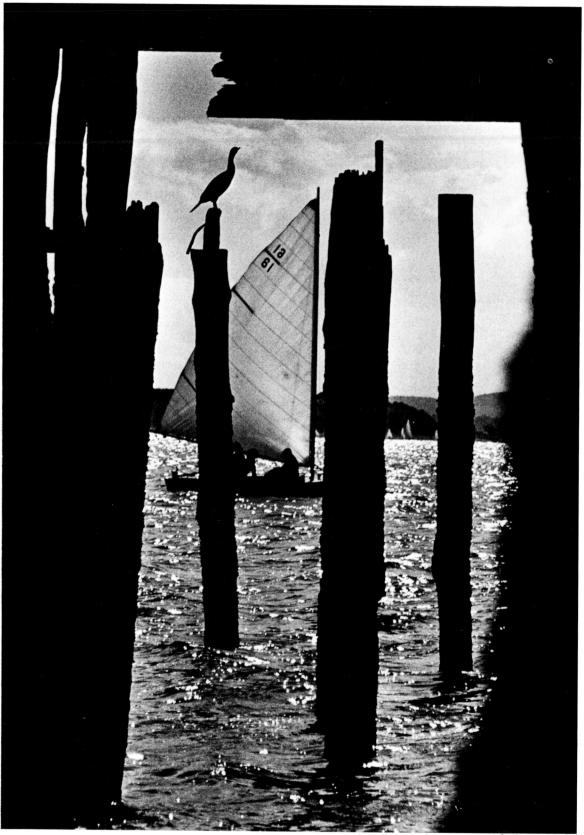

Winthrop, Mass.

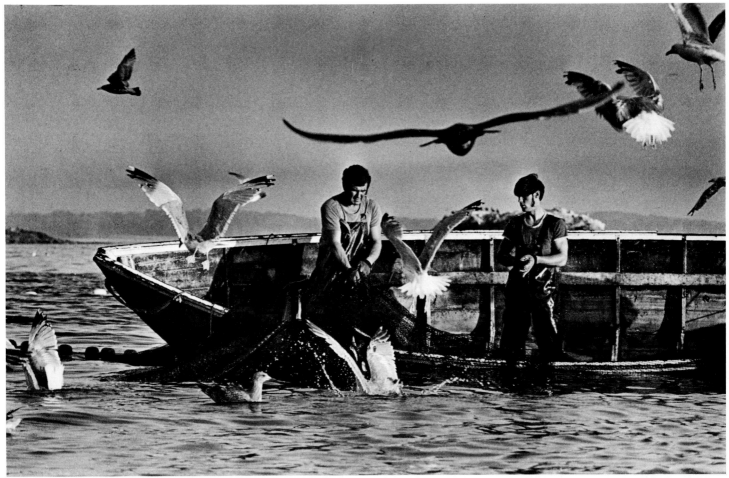

It was breakfast time off Marblehead. On land it smelled like bacon.

Marblehead, Mass.

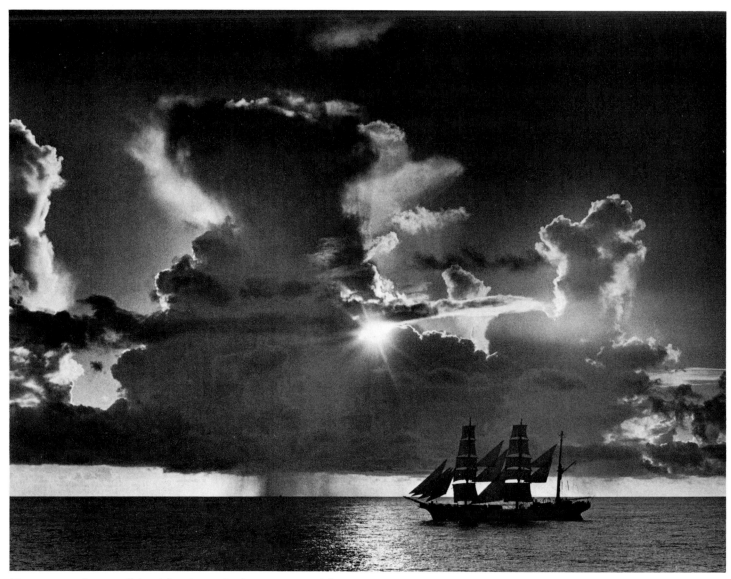

Not many people can call it a job to brown in the warm sun and focus on Tall Ships. That's where I am lucky.

"USS Eagle." Bermuda-Newport, R.I.

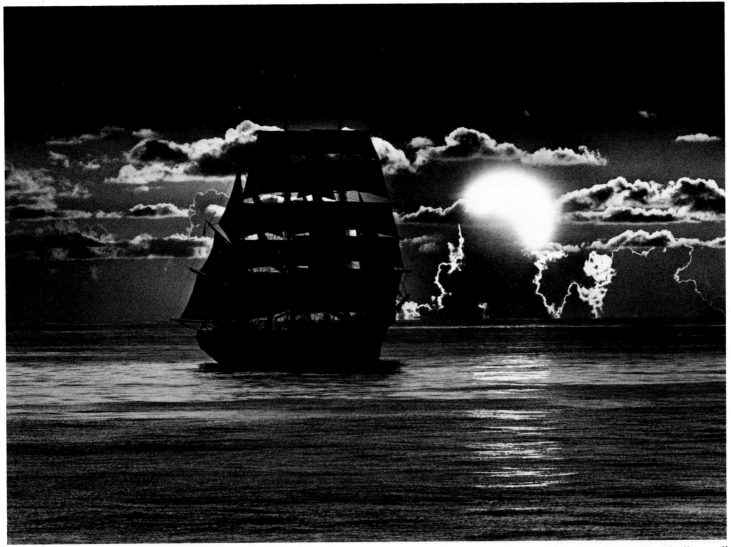

Portugese Tall Ship "Sagres"

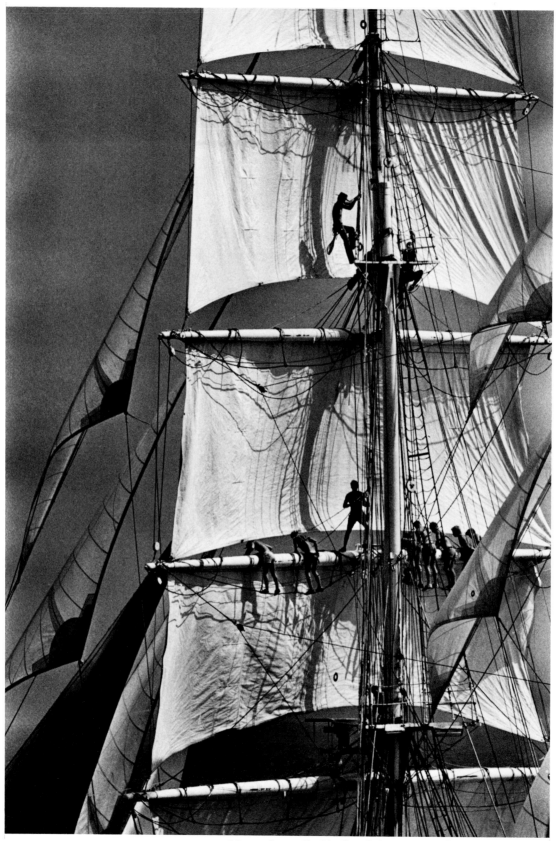

Norwegian Tall Ship "Christian Raddich." Off Newport, R.I.

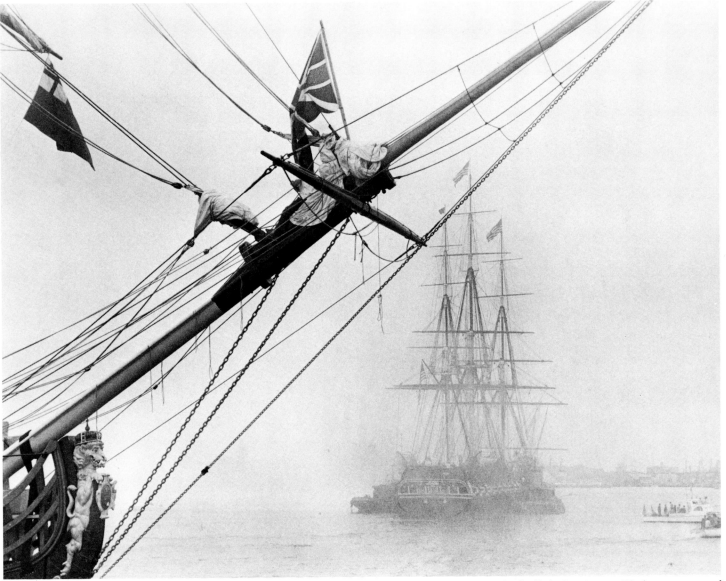

"USS Constitution" during Boston Harbor turnaround

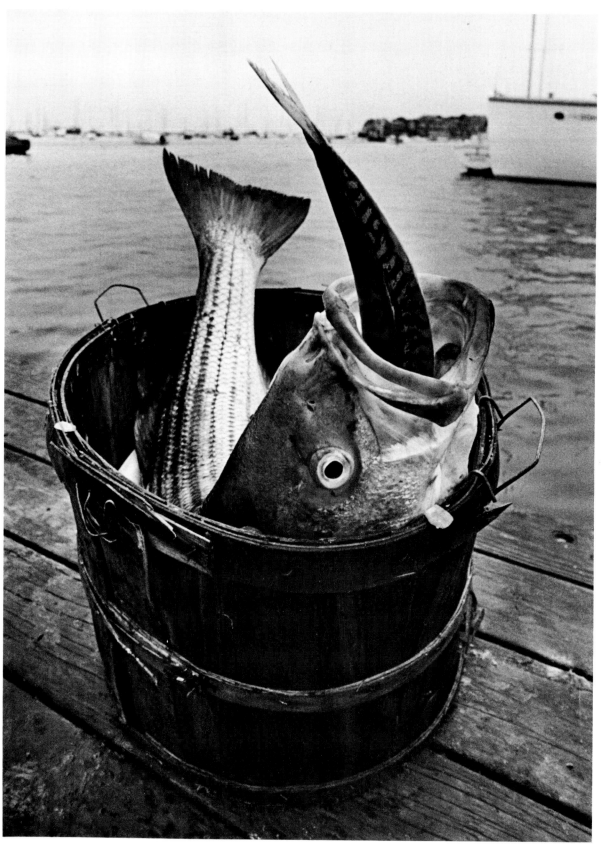

Marblehead, Mass.

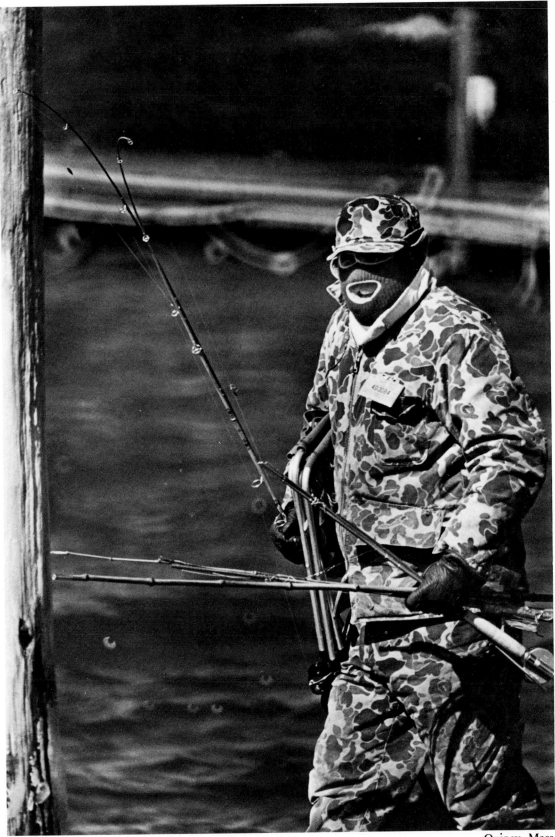

Quincy, Mass.

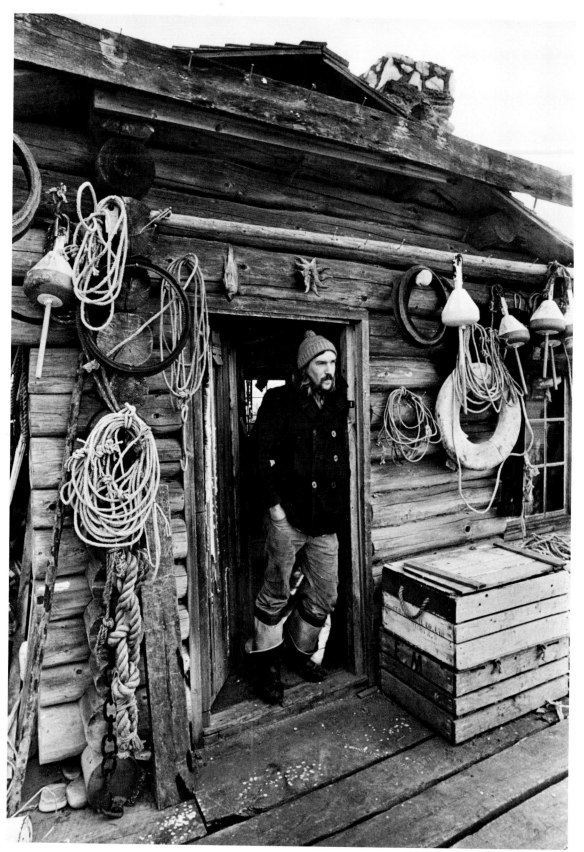

Bailey Island, Me.

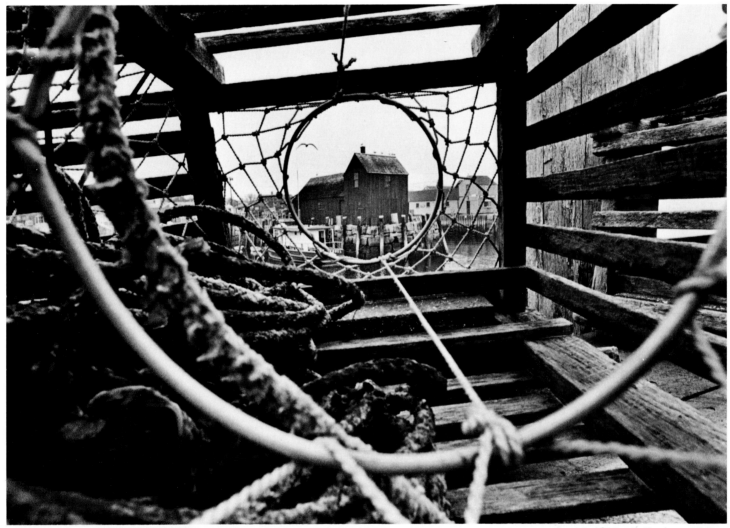

Motif No. 1, Rockport, Mass.

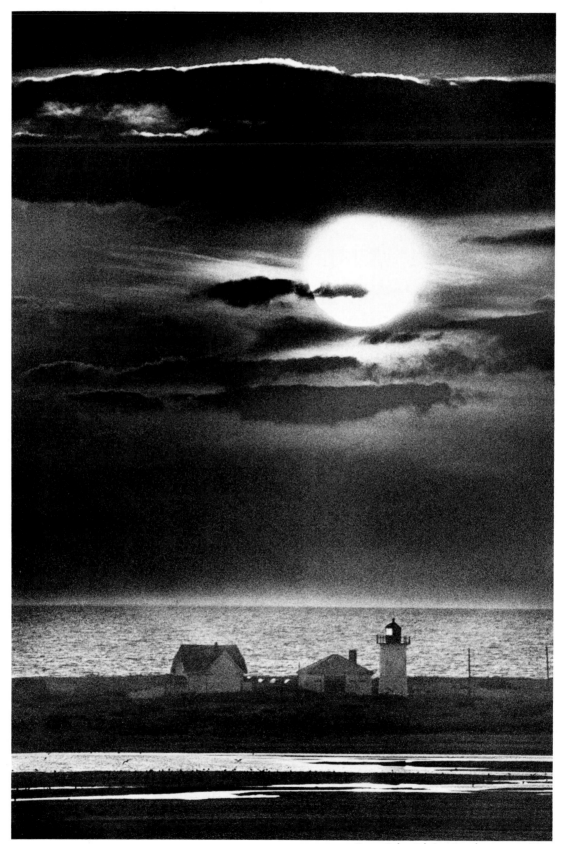

Race Point Light. Provincetown, Mass.

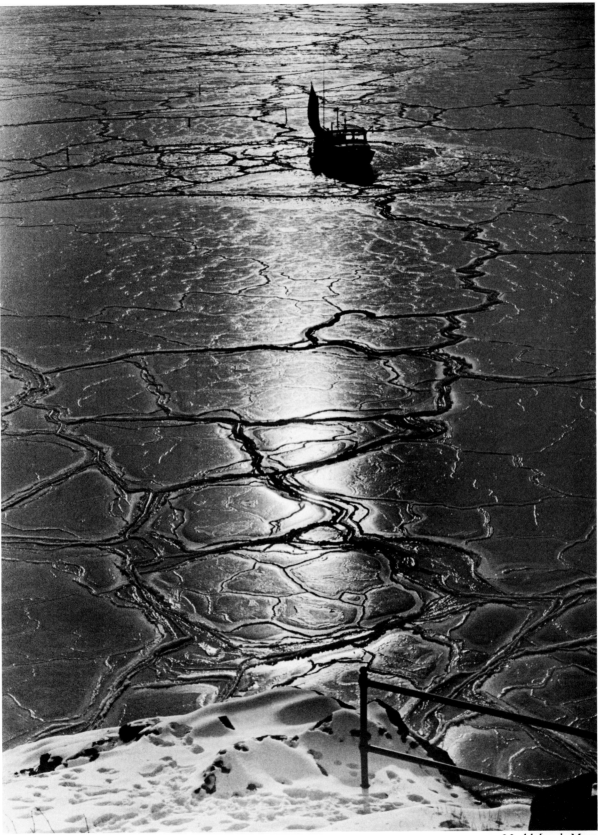

Marblehead, Mass.

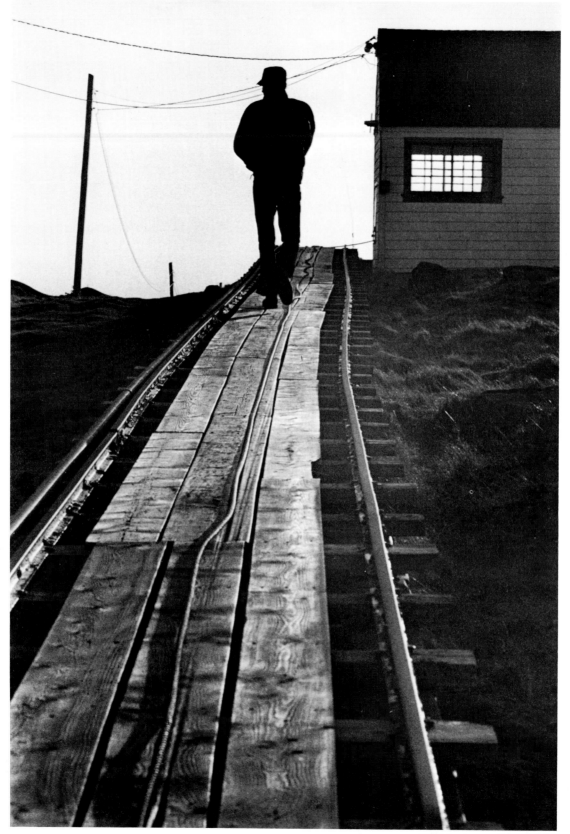

Off Monhegan Island, Me.

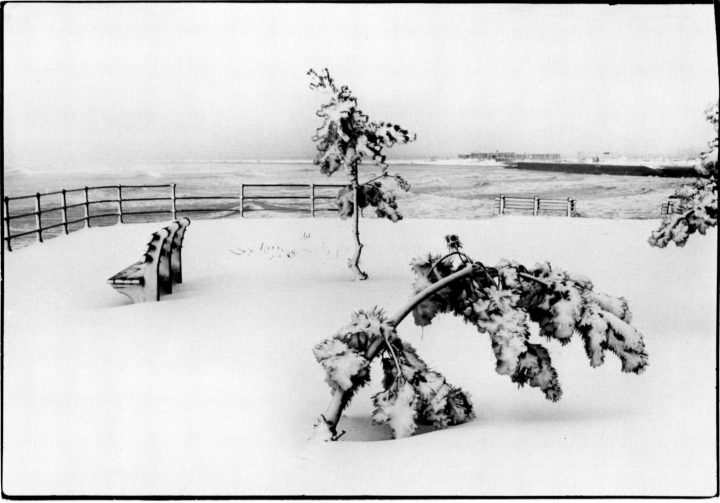

Lynn, Mass.

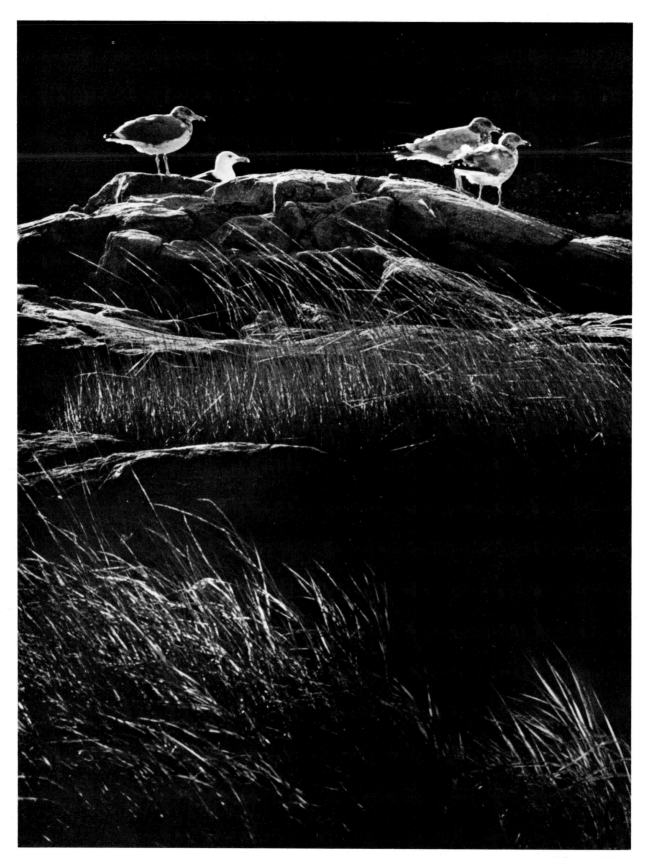

Cohasset, Mass.

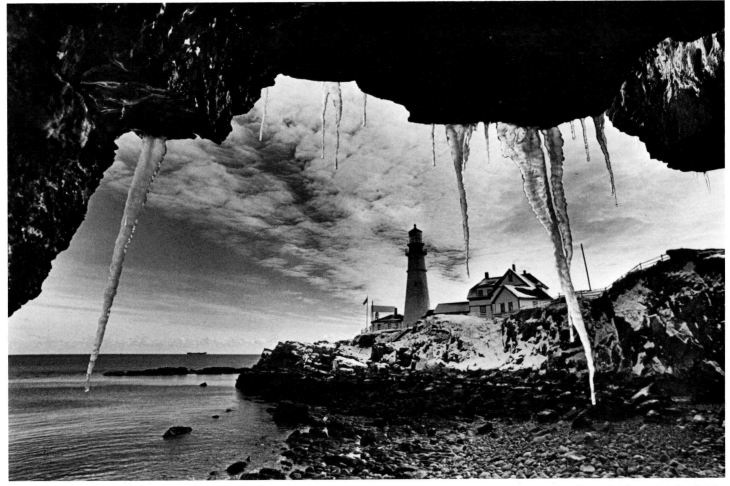

Portland Head Light. Portland, Me.

Ray Phillips lived alone on Manana Island, Maine, opposite Monhegan Island, with his gander and his sheep (following pages). He lived simply and was very sick. Even so, he welcomed me on a cold January morning. He had a good outlook on life; he enjoyed the simple things in our world. Ray often rowed over to Monhegan Island to do his errands, but he grew weaker. One winter his hands froze while rowing and he went in circles. His neighbors across the water were watching and help came. They used to watch for his lantern and one summer night they couldn't see its light flickering across the water. It was evening for Ray Phillips. He was such a neat man.

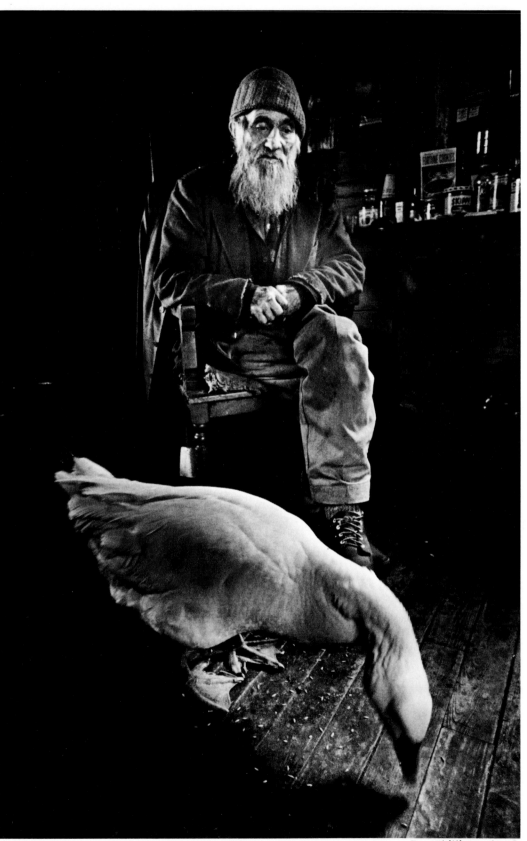

Ray Phillips at home

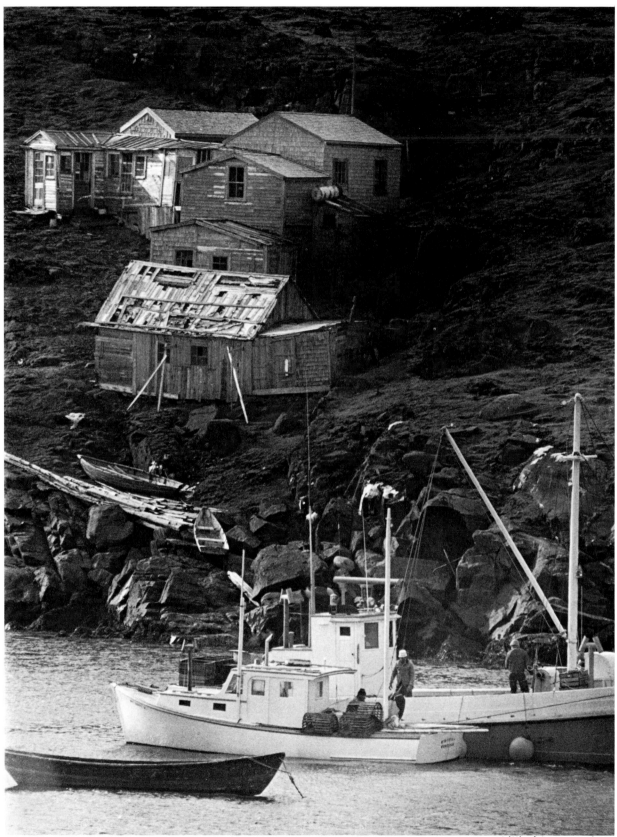

Phillips' homestead . . .

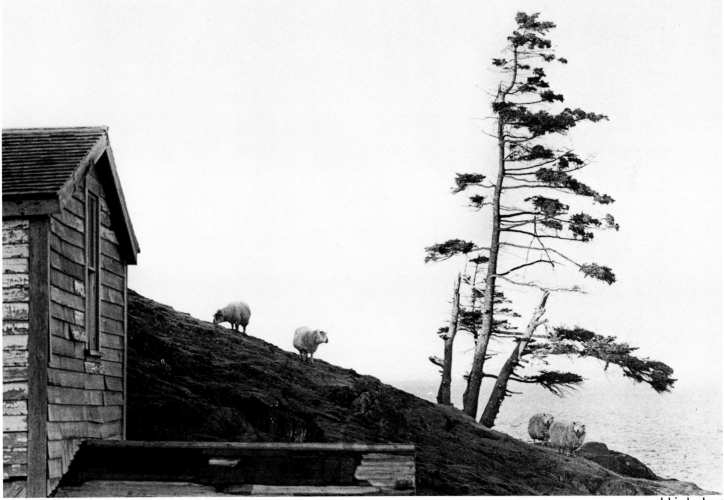

. . . and his lookout

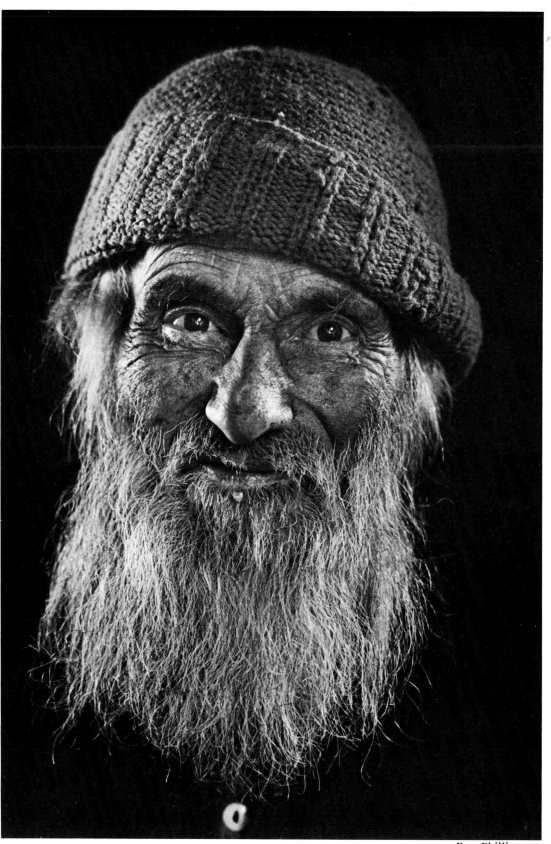

Ray Phillips . . .

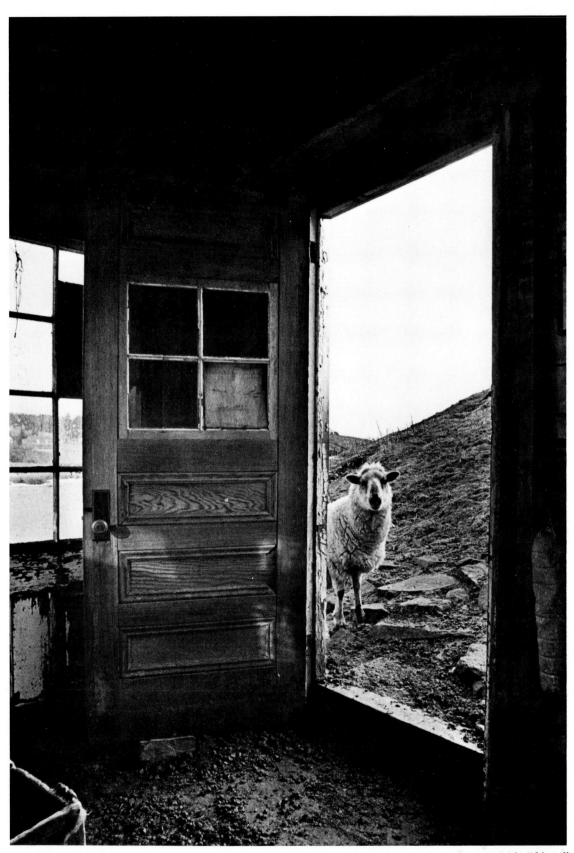

. . . and his "friend"

119

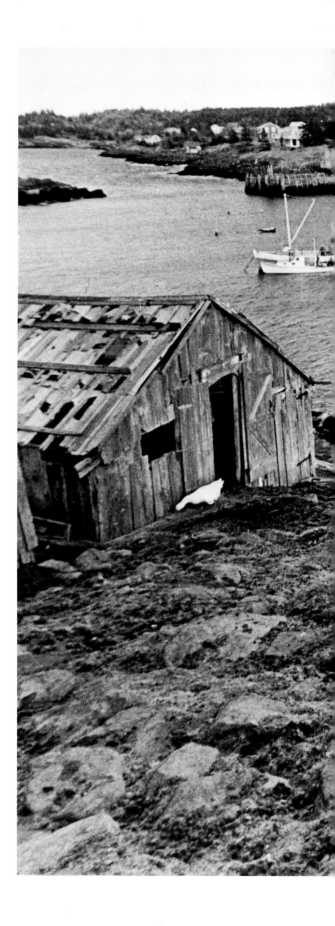

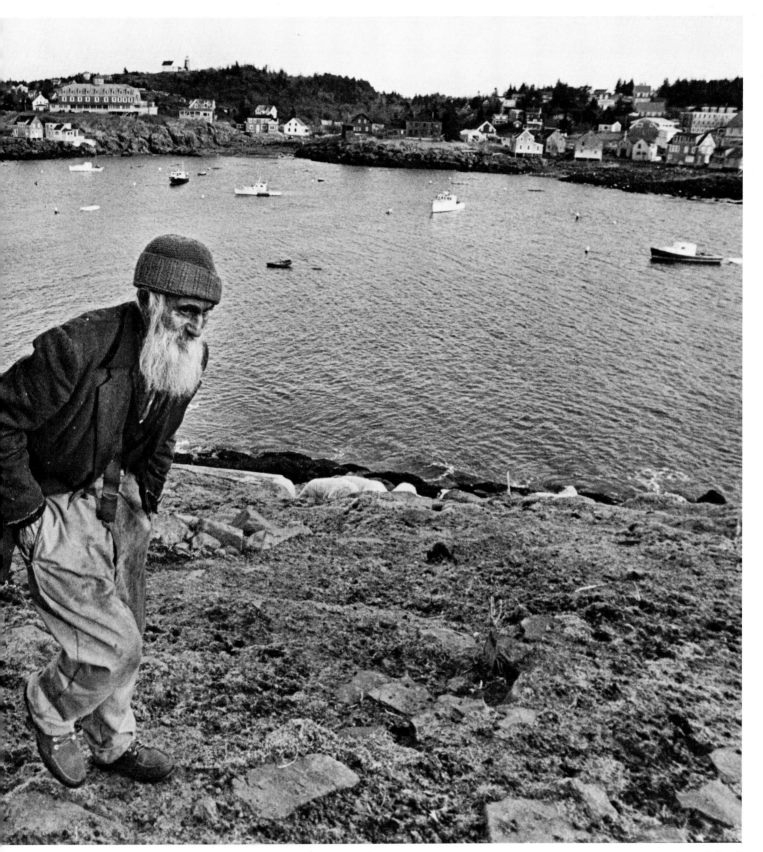

Solitude

Shop Talk

Even though I prefer the precision of the Leica rangefinder series, working for a big newspaper requires some conformity in equipment and darkroom procedures. So I regularly use the single lens reflex camera — mine is the Nikon 2.

I use a motordrive occasionally, but only to advance the film, never to run off the roll. I believe in the decisive moment when the mind and the fingertip have to coincide. I select this sensitive moment and do not let the camera do the shooting for me.

I often use the longer lens, 200mm and up. With them I can make the unimportant less strong and put emphasis on my principal subject, to come across fast and effective for the viewer. Sometimes I emphasize the foreground with an extreme wide-angle lens, the 20mm. I like to lead into my pictures, tell more about a subject with foreground or surroundings.

I very seldom use flash, but if I do, I try to bounce the light. I do use the camera light meter sometimes, but my own guessing for ASA 400 is respectable.

In developing film, I mostly use D76 straight (occasionally 1:1) and sometimes I rate the usual Tri-X ASA 400 film at 1600 ASA for very poor light conditions, and then I use Diafine developer.

For printing I have Leitz Focomats available, so that I can watch for settling dust. Dust is my enemy.

I like to present clean, crisp prints and for more impact, I burn in or dodge a lot of areas.

I personally finish all my photos to give them that extra spark, appealing to both the editors and the readers.